POSH PUPS

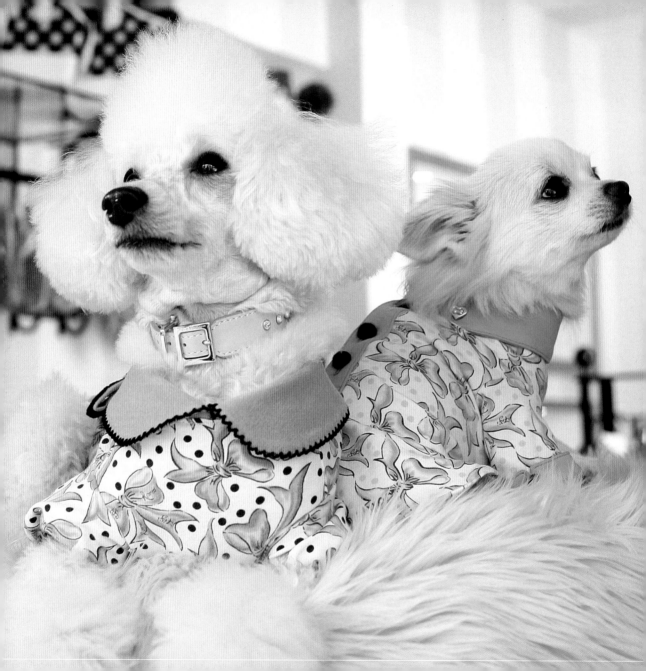

Dogs Who Live Better Than You Do

POSH PUPS

Ilene Hochberg

STERLING

New York / London
www.sterlingpublishing.com

Please note that the Web sites on these pages are current at the time of this writing; however, Web sites may be changed or taken down without notice.

Library of Congress Cataloging-in-Publication Data

Hochberg, Ilene, 1955-
 Posh pups : dogs who live better than you do / Ilene Hochberg.
 p. cm.
 Includes index.
 ISBN 978-1-4027-5079-3
 1. Dogs—Pictorial works. 2. Dogs—Miscellanea. 3. Photography of dogs.
 4. Human-animal relationships. I. Title.
 SF430.H63 2008
 636.7—dc22
 2008008863
10 9 8 7 6 5 4 3 2 1

Published by Sterling Publishing Co., Inc.
387 Park Avenue South, New York, NY 10016
© 2008 by Ilene Hochberg
Distributed in Canada by Sterling Publishing
C/o Canadian Manda Group, 165 Dufferin Street
Toronto, Ontario, Canada M6K 3H6
Distributed in the United Kingdom by
GMC Distribution Services
Castle Place, 166 High Street, Lewes,
East Sussex, England BN7 1XU
Distributed in Australia by Capricorn Link (Australia) Pty. Ltd.
P.O. Box 704, Windsor, NSW 2756, Australia

Book design and layout by *tabula rasa* graphic design

Printed in China
All rights reserved

Sterling ISBN 978-1-4027-5079-3

For information about custom editions, special sales, premium and corporate purchases, please contact Sterling Special Sales Department at 800-805-5489 or specialsales@sterlingpublishing.com.

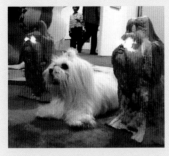

Tori

Kelly

Ilene and Bob

For Tori,
who taught me everything I know about pampering dogs.

For Kelly,
"I want to be the person my dog thinks I am."

And for my husband Bob Wood,
who inspires me every day with his actions and deeds.

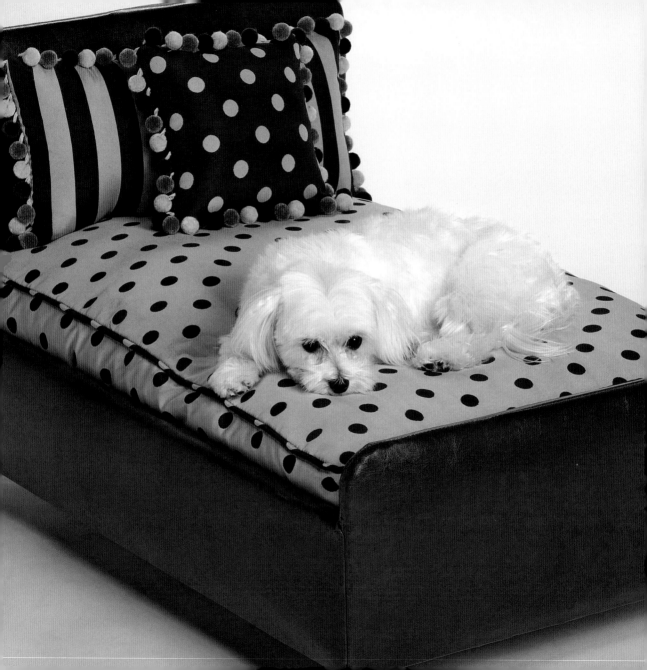

Contents

Introduction 1

Chapter 1 **A Lifestyle to Die For...** 3

Chapter 2 **Good Breeding** 11

Chapter 3 **The Clothes Make the Dog** 21

Chapter 4 **Good Grrrrooming ... You Look Fabulous, Darling!** 34

Chapter 5 **House and Grrrden** 43

Chapter 6 **You Are What You Eat** 52

Chapter 7 **Fitness for Fido** 62

Chapter 8 **Sit. Stay.** 71

Chapter 9 **Fly Me to the Moon** 81

Chapter 10 **Party Animals!** 87

Chapter 11 **Join Clubs, Make Friends...** 98

Chapter 12 **Paper-Trained** 105

Chapter 13 **Do(g) It Yourself: Arfs and Crafts** 112

Chapter 14 **Dr. Dog** 118

Chapter 15 **The Great Doghouse in the Sky** 125

Conclusion **Having It All** 133

Appendix **Complete Vendor List from Pet Fashion Week** 135

Acknowledgments 144

Index 149

Tori Hochberg

Introduction

By the time she was eight, Tori had traveled to Beverly Hills and Paris; dined in *Michelin Guide* three-star restaurants; seen countless movies; shopped in stores from Bergdorf Goodman to Galeries Lafayette; wintered in Miami Beach; yachted to lunch at The Fisher Island Club; attended parties, bar mitzvahs, and weddings; and was the subject of two magazine stories. No, I am not referring to media princess Tori Spelling. I am describing the luxurious lifestyle enjoyed by Tori Hochberg, a 4-pound Maltese—small, blonde, and spoiled like her namesake.

And she is not alone. Tori can be matched story by story, elite experience by elite experience, by countless other four-legged friends.

Pets have been revered throughout history. They were considered gods in ancient Egypt, the loyal supporters of royalty in England, subjects worthy of immortalization by artists, and the steadfast and true members of families everywhere. Dogs have provided comfort, companionship, protection, and unconditional love to all who share home and hearth with them. And for these gifts, they have been rewarded with food, shelter, and kindness. Not a bad exchange....

But who expected gourmet meals like filet mignon cut into tiny bite-size pieces and served with organic biscuits? Or that the shelter would take the form of a bed designed by Tom Ford for Gucci or a carrier created by Louis Vuitton? And who would have anticipated kindness entailing

protection from the elements in a Burberry rain-coat, a hand-knit sweater from Ralph Lauren, or a warm, leather-trimmed coat from Coach? In the old days, "a dog's life" never looked like this!

The phenomenon of "pocket pets," those dogs small enough to fit discreetly into a purse, has expanded this concept exponentially. Today, dogs can be viewed as the ultimate fashion accessory. The dog you choose as your four-legged friend is indicative of your taste, style, and status. There has been a natural progression from status watch to designer bag to prestige pup...and it seems like everyone has one. Everyone who matters, that is. Those celebrities immortalized by the media are seldom seen without their canine companions, their "handbags with a heartbeat."

Dogs can function as surrogates for children or can augment a family with kids. They are always happy to go anywhere, are delighted with even the slightest bit of attention, and will shower whomever bestows it upon them with unconditional love and loyalty. That is more than can be expected from the fickle public, coworkers, business associates, friends, and even family. There is truth in the often-repeated statement, "If you want a friend in Washington, get a dog."

Living large is easy, if you know what you (or your dog) want and how to get it. But if you don't, this is the book for you. *Posh Pups* will examine every facet of the luxurious lifestyle and show you where to find opulent options and buy the best of everything. But if budget is a consideration (and truly, it is for many of us), this book will offer a bare-bones way to find the look for less.

So, curl up with this tell-all guide, and learn how your dog, too, can have it all. Your best friend, after all, deserves to be pampered!

A Lifestyle to Die For...

W hat do you have in common with Paris
Hilton, Tori Spelling, Bruce Willis, Nicole
Richie, Britney Spears, Jessica Simpson,
Beyoncé, Martha Stewart, Jake Gyllenhaal, Oprah
Winfrey, Halle Berry, Sandra Bullock, Sylvester
Stallone, Julianne Moore, Jennifer Aniston,
Courtney Cox, Drew Barrymore, Hilary Duff,
Debra Messing, Mariah Carey, Edie Falco, Rupert
Everett, Heidi Klum, Kate Bosworth, Salma Hayek,
Penelope Cruz, Gwen Stefani, Sheryl Crow,
Courtney Love, Natalie Portman, Joan Rivers, Mary
Tyler Moore, James Gandolfini, Adam Sandler,
Mickey Rourke, Billy Joel, Ozzy Osbourne, Serena
Williams, Ellen De Generes, Star Jones Reynolds,
Debbie Harry, Valentino, Yves Saint Laurent, Oleg
Cassini, Marc Jacobs, Pablo Picasso, Queen Victoria,
Queen Elizabeth, the late Duke and Duchess of
Windsor, and Marie Antoinette? You have all shared

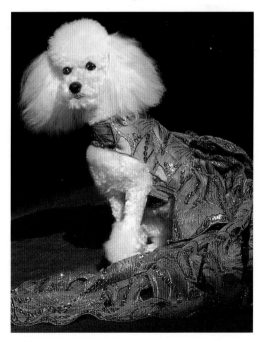

Meet Precious.

your lives with special dogs. And the list could go on to comprise many more notable people, including virtually all U.S. presidents, plus countless sports figures, musicians, artists, and writers.

Why have all of these people chosen to share their life with a beloved dog? Perhaps it can be explained most simply by examining the nature of fame and fortune. People who are rich and famous are often sought out by others who would hope to share in their money and notoriety. People often gravitate toward celebrities simply because they are rich and famous, without regard for any of their more human qualities. High-profile people may be reluctant to form relationships with strangers, fearing that they are being approached only because they are well known. For this reason, celebrities seem to socialize primarily with each other and with friends and family members who knew them before they were famous. This policy can substantially cut down on their social interaction.

By contrast, dogs are selfless and nonjudgmental beings. They love us simply because we care for them and because we have chosen to invite them into our lives. Our dog does not care if we are rich or famous. Dogs love us unconditionally, simply because we are their people. There is a purity in this interaction that does not exist in interpersonal relationships, and for many famous people, this is very compelling.

Luxe Life

Celebrities go everywhere with their furry best friends, often toting them along in specially designed bags and outfitted in designer collars, leashes, sweaters, coats, and T-shirts from an ever-increasing list of suppliers, which includes the well-known designers Ralph Lauren, Gucci, Hermes, Louis Vuitton, Tiffany, Burberry, Coach, Juicy Couture, and many more. These fashionable designer accessories can be very expensive and beyond the means of most dog owners.

While celebrities can afford to provide their furry best friends with anything that money can buy, we all like to indulge our dogs within our means. One lucky dog is Precious, the 4-pound, white Teacup Poodle whose photos grace the beginning of almost every chapter in this book. Think of Precious as your guide to the best of everything available for your dog. Each chapter will include a glimpse of Precious and insight

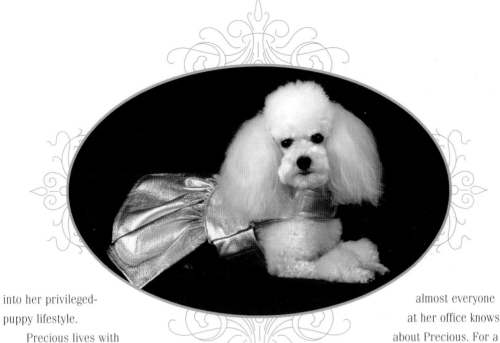

into her privileged-puppy lifestyle.

Precious lives with her dog mother, Cindy, in southern California. Precious is the two-and-a-half-year-old love of Cindy's life, more "furry child" than pampered pup. Cindy describes Precious as "part princess, part diva, totally spoiled-rotten poodle," and she likes her that way.

Cindy is an aerospace engineer working on the Global Hawk Program, a government/military project, the goal of which is to design an unmanned air vehicle, the wave of the future. She works with more than 5,000 people, and almost everyone at her office knows about Precious. For a while, Cindy wrote an online blog about her beloved dog. Precious received letters from more than 100 members of her fan club, and Cindy maintains an e-mail file of her dog's fan mail.

Cindy dates someone famous, who is accustomed to being the center of attention. However, when the three of them go out on the weekend or dine at outdoor restaurants, people flock to see Precious, resplendent in one of her couture dresses or evening gowns from the designer

CHEAP CHIC

You do not have to spend a ton of money for your precious pup to look like a million bucks. Many manufacturers offer designer knockoffs of exclusive designer pet fashions. Target carries several lines of high-style clothing and pet accessories at low prices, both in stores and online at www.target.com. Mass merchants like Wal-Mart and Kmart also offer attractive designer items for pets, as do most chain pet stores (PetSmart is one) and local pet shops. Stores better known for providing inexpensive fashions for people have also embraced pampered dogs; Old Navy is only one of many such retailers to include dog clothes and accessories in their product offerings. Sherpa's Pet Trading offers lower-priced lines of its popular designer pet travel bags at many pet stores and online at www.sherpapet.com.

Emma Rose, worn with a matching Swarovski crystal necklace and tiara. Precious gets as much attention as Cindy's boyfriend!

Precious is fortunate to have a dog mother who is able to provide her with exclusive pet products and services. Yet, not all dog owners can afford to purchase expensive indulgences for their pets. The demand for special pet products has resulted in the creation of luxury items available at popular prices. The designer Isaac Mizrachi has made the designer experience available to all dog owners through his line of pet products created for Target stores. And this is only one example of the affordable extravagances now available at the pet, grocery, or chain store nearest you.

Whether you're looking to indulge your dog with designer duds or organic entrées, almost anything that is available for people is now available for our pets. Luxury hotels? Check. Gourmet meals? Check. Spa treatments and exercise with a personal trainer? Check. Designer wardrobes? Check. Bling (expensive jewelry and other accoutrements)? Check. "It" bags (fashion handbags)? Check. Custom-designed houses, beds, dishes, and more? Check, check, check, and check. And the list goes on and on.

Doggie Data

Why is the market for pet products so massive? Just look at the numbers. According to the latest study on pet ownership conducted in 2006 by the American Pet Product Manufacturers Association (APPMA), there are 73.9 million dogs in the United States. In fact, 43.5 million households own a dog (39 percent), compared to 37.7

CHEW ON THIS
Dogs of the World

How are our furry friends represented around the world? Here's a random sampling:

* The United Kingdom boasts 6.8 million canines.
* In Australia, there were 116,375 purebred dogs registered in 2006.
* Japan is home to 13 million dogs. The Japanese spent a hefty $10 billion on pets in 2006.
* The United States has 73.9 million canine residents. In 2006 Americans spent $41 billion on their pets.

million households that own a cat (34 percent), 14.7 million that own fish (13 percent), 6.4 million that own a bird (6 percent), 4.2 million that own a horse (4 percent), 5.7 million that own a small animal (5 percent), and 4.4 million that own a reptile (4 percent). And pet ownership is

on the rise. In 1988, the year these figures were first researched by the APPMA, 56 percent of U.S. households owned a pet, compared to 63 percent in the 2006 report.

Furthermore, people are astonishingly committed to their pets. According to a Harris Poll conducted for Hartz Mountain Industries, Inc., in 2005, 75 percent of pet owners refer to them as members of the family. Thirty-one percent of the people polled admitted that they spend more time with their pets than they do with their spouse or significant other. Thirteen million considered their pets to be their very best friend, and 31 percent said they would take their pet to work with them if they could. And, according to the American Bar Association, 25 percent of pet owners make provisions for their pets in their wills.

Pricey Pups

All of these dearly loved dogs contribute to a thriving pet-care industry. Last year Americans spent $41 billion on their pets, which, according to an article in *Business Week* magazine, is "more than the gross domestic product of all but 64 countries in the world." That's a lot of biscuits!

The article goes on to point out that this figure "puts the yearly cost of buying, feeding, and caring for pets in excess of what Americans spend on the movies ($10.8 billion), playing video games ($11.6 billion), and listening to recorded music ($10.6 billion) combined...and that annual spending on pets should hit $52 billion in the next two years.... After consumer electronics, pet care is the fastest growing category in retail, expanding about 6% a year."

As you can see, dog ownership is not an inexpensive venture. According to a study from the American Kennel Club (AKC), one-time costs, which include purchase price or adoption fees, spaying and neutering expenses, emergency vet visits and surgeries, training fees and equipment, and general supplies (crates, bowls, leashes, collars...), add up to an average of $2,127 per dog. Annual expenses, which include food, vet care, travel, grooming, pet sitting, walking, boarding, toys and treats, ongoing training, and dog events, add up to another $2,489 on the average each year. Your dog can live eighteen years or more (if it is a small breed), so you are making a substantial monetary investment in this relationship. If you are like most people who own dogs, you will find it money well spent.

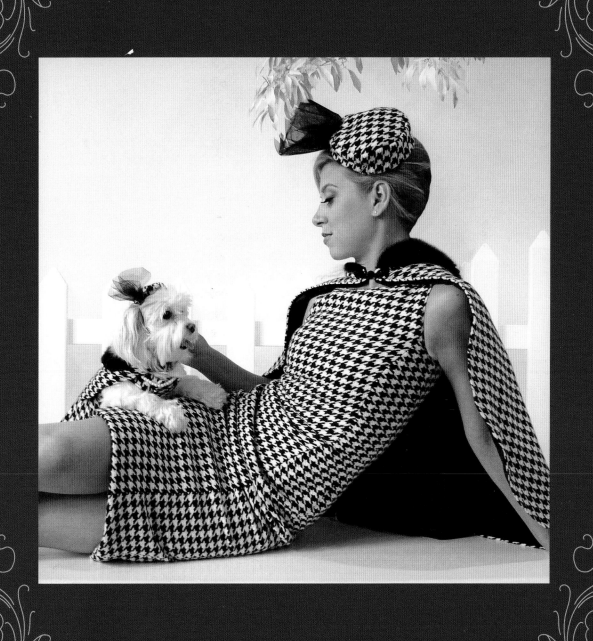

But how will you choose to spend that money? On generic bagged dry food from the local discount chain or on gourmet entrées such as Lasagna with Wild Boar Meat, Rigatoni Pasta with Grouper, or, for the vegetarian pup, Cheese Tortellini Pasta with Walnuts? Perhaps your furry friend would prefer Grammy's Pot Pie, French Country Café, or Thanksgiving Day Dinner? These savory entrées are only a small sampling of the hundreds of choices shown at the recent Global Pet Expo, co-hosted by the APPMA and PIDA (Pet Industry Distributors Association). More than 377 manufacturers specializing in products designed for dogs were represented at the most recent trade show of pet products.

The pet products marketplace is exploding with extraordinary products that have been developed to satisfy your dog's every need, and to fulfill needs you never knew existed. Your dog deserves the best for being such a devoted and selfless companion. The following chapters will show you how to pamper your pup in extraordinary ways. Some products, services, and experiences will be beyond the economic means of most pet owners, but most will be affordable for anyone who wants to pamper their four-legged best friend.

Good Breeding

In January of 2007, the American Kennel Club (AKC) announced the top-ten most-popular dog breeds in the United States. Topping the list for the sixteenth year in a row was the Labrador Retriever. The number-two dog, however, was a surprise. The Yorkshire Terrier overtook perennial favorites, including the German Shepherd (#3) and the Golden Retriever (#4), signaling a change in the tastes of American dog owners. The remaining top ten were the Beagle (#5), the Dachshund (#6), the Boxer (#7), the Poodle (#8), the Shih Tzu (#9), and the Miniature Schnauzer (#10). Why are our favorite dogs suddenly "shrinking"?

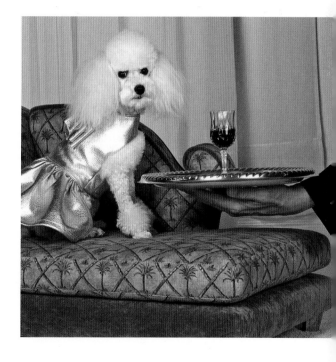

CHEW ON THIS
Pint-Size Pups

Toy dog breeds—the tiniest members of the canine family, comprising twenty-one of the smallest breeds under 20 pounds—include the Affenpinscher, Brussels Griffon, Cavalier King Charles Spaniel, Chihuahua, Chinese Crested, English Toy Spaniel, Havanese, Italian Greyhound, Japanese Chin, Maltese, Miniature Pinscher, Papillon, Pekingese, Pomeranian, Pug, Shih Tzu, Silky Terrier, Toy Fox Terrier, Toy Manchester Terrier, Toy Poodle, and Yorkshire Terrier.

Doggie Downsizing

Small dogs have held four of the top-ten spots in AKC registrations for the last four years. Two of those breeds are members of the toy group—the Yorkshire Terrier (#2) and the Shih Tzu (#9)—and joining them is the smallest member of the hound group, the Dachshund (#6). The #10 dog is the Miniature Schnauzer, and the #11 dog is the Chihuahua, which held the #10 spot in last year's survey. Small breeds have not seen this level of popularity since the 1950s and 1960s, when the Boston Terrier, Dachshund, Chihuahua, and Pekingese were consistently in the top ten, occasionally joined by the Pomeranian and the Miniature Schnauzer.

This trend toward pint-size pups is at least partly fueled by the media attention lavished upon small dogs carried on the red carpet by countless celebrities. High-profile media darlings like Paris Hilton, Beyoncé, Madonna, Britney

Dachshund

Spears, Halle Berry, Nicole Richie, Tori Spelling, and Star Jones Reynolds are only a few of the people photographed everywhere with their small dogs in hand. In addition, small dogs are popular in urban households. Toy dogs have been bred specifically as companions, and their small size permits people to take them to establishments that might not welcome larger dogs.

Indeed, many owners of toy dogs take them everywhere they go, from work to stores,

Chihuahua

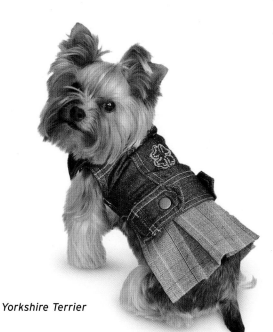

Yorkshire Terrier

restaurants, hotels, movies, and anywhere else they may visit in the course of a day. This is certainly true in the case of Precious, the Teacup Toy Poodle who graces the beginning of every chapter in this book. Precious accompanies her owner, Cindy, everywhere, with the exception of work—from the grocery store to the hair salon, the park, the country club, and on evenings out on the town. Everywhere.

While small dogs are infinitely more transportable than larger varieties, they are also more fragile and, being so, require special care. Small dog breeds are not recommended for families with young children, because children can accidentally injure a tiny dog with rough treatment. They are at risk of being crushed or smothered when sharing a bed with their human companions.

Toy dogs are also more susceptible to illness and digestive ailments, and have more difficulty bearing puppies than larger dogs. The smaller breeds require lots of companionship and do not fare well when left alone for long periods of time. Housebreaking is sometimes difficult, but key to the ownership of very small dogs, because they may be reluctant to relieve themselves outdoors, where they may not feel safe.

Small dog breeds may be perceived as less expensive to own than larger dogs, which consume

Above: *Boston Terrier*
Opposite: *Shih Tzus*

CHEW ON THIS

Dog Stars

The media is often responsible for creating and popularizing dog-breed trends. For example, the release of the film *101 Dalmatians* in 1996 was followed by a subsequent surge in Dalmatian ownership. Indeed, after the popularity of the film subsided, the Dalmatian saw a 97 percent decrease in registrations over the following ten years. Conversely, small dogs (those under 25 pounds) experienced a steady rise in registrations over the same time period. The most dramatic increases can be found in the Cavalier King Charles Spaniel (a 735 percent increase), the French Bulldog (a 305 percent increase), the Brussels Griffon (a 231 percent increase), the Papillon (a 132 percent increase), the Chinese Crested (a 100 percent increase), and the Norwich Terrier (a 91 percent increase).

Left: *Cavalier King Charles Spaniels*

Right: *French Bulldog*

far greater quantities of food than their diminutive counterparts. However, this apparent saving is offset by the longer life of small breeds, which can mean additional years of food, veterinary care, supplies, and just plain pampering by their often-indulgent owners.

Living Large

Large dogs present their own unique challenges and special benefits to their owners. These dogs require greater quantities of food, more exercise and time spent outdoors, and stringent training for both housebreaking and obedience in order to make them well-behaved family members. However, because they are less fragile (and therefore can handle rough play), they can be good choices for children. In addition, larger dogs provide their owners with protection—and they make great exercise companions.

Potential pet owners should examine their own domestic situations, personal needs, and expectations when determining the right-size dog for their family.

Right: *Labradoodle*

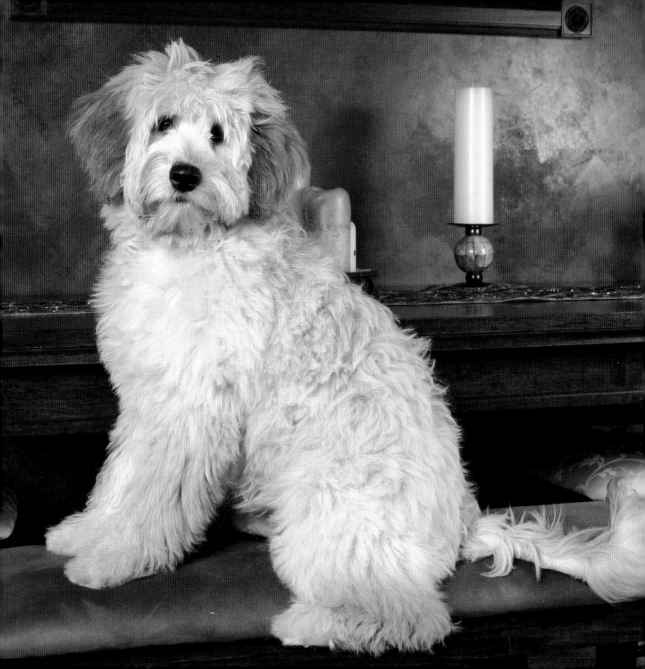

It's All in the Mix

A dog does not have to be purebred to be a best friend. Mutts, or dogs of indeterminate lineage, can be adopted from the local humane society, and these dogs will repay your kindness with love and devotion. Another choice is to purchase a mixed-breed dog from a store or breeder. These "designer dogs" are the newest category of canines and are created by the deliberate crossbreeding of two purebred dogs of different breeds. The resulting puppies are said to combine the traits of both parents' breeds. These dogs are bestowed with cute names that often reflect their genetic origins, such as Labradoodle (Labrador Retriever/Poodle), Goldendoodle (Golden Retriever/Poodle), and Puggle (Pug/Beagle), to name only a few.

Your Dream Dog

How do you determine the best dog for you? One way is to read about the characteristics and traits of all the purebred dogs. This is best

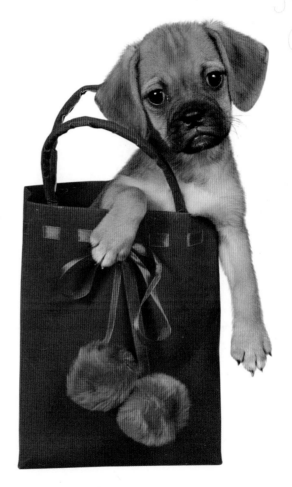

Above: *Puggle*
Opposite: *Goldendoodle*

accomplished on the AKC Web site www.akc.org or by reading one of the many books available that describe all the dog breeds. Perhaps one of the best is the book written and distributed by the AKC, *The Complete Dog Book* (available at bookstores or online). The AKC also provides lists of reputable dog breeders. You can consult these lists when attempting to find a purebred puppy. Our favorite Toy Poodle, Precious, was located through this long-established method.

Other ways to learn about dogs include questioning your veterinarian, speaking to people at your local humane society, or asking friends who own dogs about their chosen breeds. Several Web sites will also provide you with basic information about dog breeds, including www.dogbreedinfo.com, which features a brief questionnaire that can help you locate the right dog for your needs. You can find out about the top-twenty mixes of "designer dogs" by reading my book *Dogs by Design*, which also contains information about the purebred dogs that create these hybrids.

You also may need to take health factors into consideration when choosing a dog for yourself. According to the AKC, breeds that are less prone to shedding are better choices for people with allergies; these include the Bedlington Terrier, Bichon Frise, Chinese Crested, Irish Water Spaniel, Kerry Blue Terrier, Maltese, Poodle, Portuguese Water Dog, Schnauzer, Soft Coated Wheaten Terrier, and Xoloitzcuintli. And for those with other medical considerations, take heart: Dog ownership is good for your health. Studies have concluded that pets help to lower blood pressure, reduce stress, prevent heart disease, lower health-care costs, and fight depression.

❀ ❀ ❀

By now you should be convinced, if you do not already share your life with a dog, that it's time to bring one into your home and heart. Only then can you understand the joy in loving and pampering a pup. Now let's turn to specific ways to do just that.

The Clothes Make the Dog

There was once a time when dog clothes
meant a red acrylic turtleneck sweater to
keep Fido warm in the winter. Those days
are long gone. Today's Fhydeaux may wear a
hand-knit cashmere sweater from Ralph Lauren
on Monday, a wool tweed coat trimmed in leather
from Coach on Tuesday, a jacket from Isaac
Mizrahi on Wednesday, a raincoat from Burberry
on Thursday, a fine leather collar and leash from
Hermès on Friday, a logo canvas coat with a
matching hat from Gucci on Saturday, a clever
collar and leash from Louis Vuitton on Sunday,
and still have a closet packed with outfits to wear
for the rest of the winter. Then comes spring,
when lightweight outfits in happy colors replace
the heavy clothes of the previous season.

According to a report commissioned by the
APPMA, more and more companies traditionally

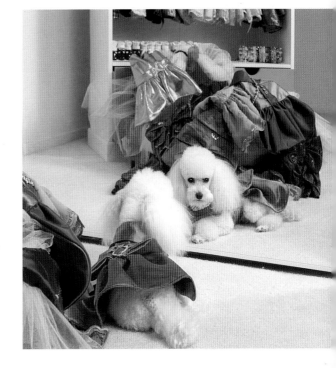

known for human products are creating lines of similar products for pets. These include famous designers like the ones mentioned above, as well as Target (with Isaac Mizrahi designing clothes and pet accessories exclusively for the chain), Old Navy, Harley-Davidson, John Deere, Tiffany & Co., Burberry, Brooks Brothers, Orvis, L.L. Bean, Disney, Spiderman, Juicy Couture, Snoop Dogg, the AKC, and many more.

A recent article in the *New York Times* called "Woman's Best Friend, or Accessory?" profiled six women in New York City who indulged their small dogs with opulent clothes

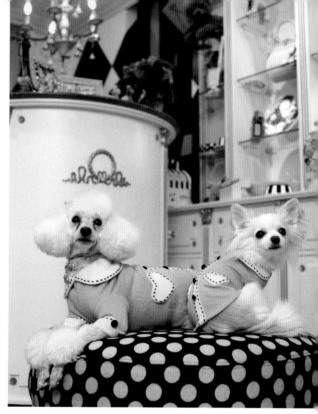

A Fifi and Romeo store

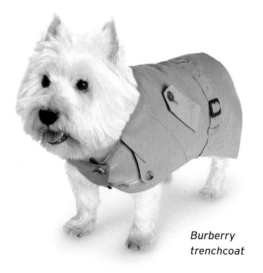

Burberry trenchcoat

and accessories. One woman provided her small dog with a small garment rack, replete with miniature hangers to hold her wardrobe; another woman shares her closet with her dog, which has more than forty outfits. These women are not alone in their obsession with pet fashions.

Hollywood Fashion Hounds

Fifi and Romeo is a designer pet shop in Beverly Hills, California. The founder is a Russian émigré named Yana, who was the costume designer for several movies and television shows, including *Ally McBeal.* She decided to cut up her own cashmere sweater to make a small sweater for her beloved Chihuahua, Yoda. Soon, Yana was making small sweaters and other tiny items for friends' dogs. Before long, she was asked to design the costumes and accessories for Bruiser, the Chihuahua in the Reese Witherspoon film *Legally Blonde,* and the rest is history. Her shop was born. The store has recently expanded into several satellite outposts in Japan, where people are small-dog obsessed. The shop also maintains an elaborate Web site, www.fifiandromeo.com, on which you can see the stores and then view and purchase their exclusive products. You can also read an almost endless list of celebrity customers who have bought things for their own dogs or as gifts. Many, including Prince Charles, Oprah Winfrey, Elton John, Paula Abdul, Christina Aguilera, Rosanna Arquette, Cameron Diaz, Anne Heche, Paris Hilton, Rachel Hunter, Bernadette Peters, Britney Spears, and Tori Spelling, appear in pictures clutching their pups or purchases. There's even a picture of Gidget, the Taco Bell Chihuahua. (The dogs themselves have even been called "celebrities' accessories.")

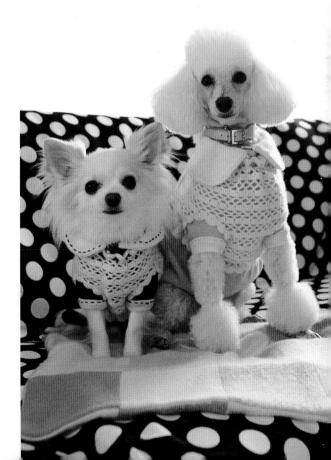

CHEW ON THIS
Wigged Out

Is your pup having a bad hair day? If so, you can treat it to a doggie wig, offered by a company called Wiggles. The idea is the brainchild of famed Hollywood hairstylist Ruth Regina. She has tamed the tresses of celebrities like Jennifer Lopez, Heidi Klum, Judy Garland, Elvis, and Richard Nixon! Your dog can choose from a range of styles with names like the Yappy Hour, Doll Face, Pink Panther, and Peek-a-Bow-Wow. One design was inspired by Donald Trump's comb-over, and another by Shirley Temple's ringlets. See the entire collection at www.wiggles dogwigs.com.

Canine Couture Collections

Perhaps the best indication that demand for pet fashions has exploded is the creation of an event called Pet Fashion Week, which debuted in August of 2006 in New York City. More than

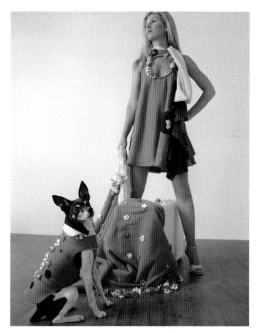

Pet Fashion Week
(this page and opposite)

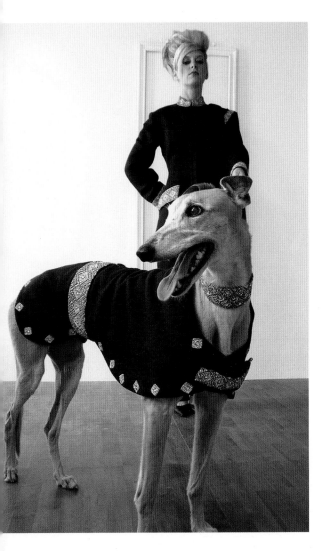

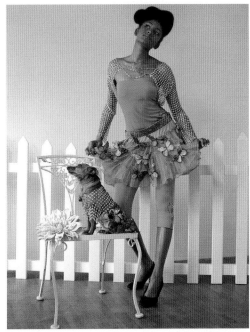

129 manufacturers were represented from all over the United States, as well as Canada, the Netherlands, the United Kingdom, Korea, Hong Kong, New Zealand, Denmark, Iceland, and other countries. The trade show attracted close to 1,500 attendees spanning twenty-two countries and five continents.

As of this writing, plans were under way for the 2007 show, once again to be held in New

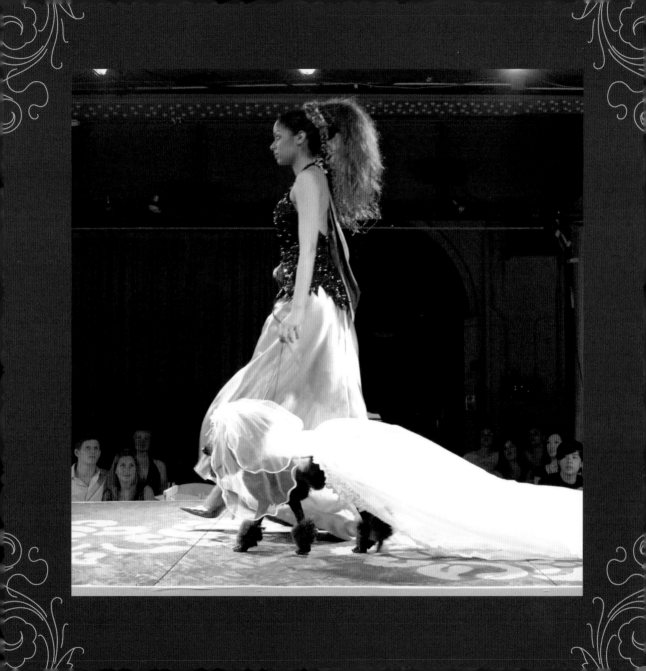

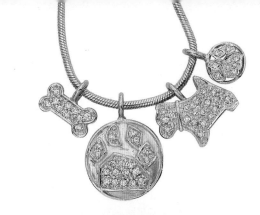

York City, where producers were expecting close to 3,000 attendees, including international and domestic buyers for department and specialty stores, pet boutiques, gift stores, and members of both trade and consumer media.

The 2006 event consisted of an extravagant runway fashion show, with creations from twenty-nine manufacturers, modeled by an array of dogs, large and small, accompanied by human fashion models dressed in coordinating outfits. The show even ended with a traditional "bride" adorned in a gown from Emma Rose Design. A symposium called Crystallized, presented by world-renowned manufacturer Swarovski, one of the corporate sponsors of the event, explored the most effective use of rhinestones on pet garments. Additional corporate sponsors included several trade and consumer-based pet magazines, manufacturers of pet products, and public relations firms. At the end of the three-day event, two awards were presented: the Pet Fashion Week Innovation Award, and the Media Choice Award, sponsored by Swarovski. There was also a Creative Styling Showcase and Live Art Exhibit to display the talents of groomers and stylists.

Pet Fashion Week is the creation of Mario DiFante, a celebrity dog groomer and pet-industry

Jewelry from Andrea Levine

veteran, and Alexa Cach, a longtime fashion-industry professional who produces fashion shows for women's ready-to-wear designers. The two saw the necessity of a trade show dedicated to the high-end designs of the pet-products market-

place. Pet Fashion Week, which closely emulates the Fashion Week for women's wear on Seventh Avenue in New York City, was the result.

The event was highly exclusive, with admission granted only to industry professionals who had preregistered with appropriate credentials. Photo IDs were required for entry to the trade show and runway events, just like the New York Fashion Week held for women's clothing designs in the spring and fall.

The innovative trade show attracted a tremendous amount of media attention, with stories appearing in trade magazines, consumer-based pet magazines (such as *Dog Fancy*, *Modern Dog*, *Wag*, *Lucky Dog*, *NY Dog*, *Hollywood Dog*, *Chicagoland Tales*, and *Boca Dog*), lifestyle magazines, newspapers (including the *New York Post* and *Chicago Sun-Times*), and the international press (from Russia's *Zoo Inform* to the *South China Morning Post*), and on television (VH1 and the *CBS Early Show*).

The clothes presented on the runway were diverse, ranging from the frilliest of ball gowns to sleekly minimal sheaths, op-art mini-dresses, and leather biker jackets—and these were the designs worn by the dogs! Photos of these amazing creations, shown here, are only indicative of the vast array of fashions that were

Poochey Shoos

Above and right:
Oscar Newman Designs

more than 300 outfits and fifty or more collar-and-leash sets, to match her outfits, of course. Cindy's favorites are the ones custom-made for Precious by Emma Rose Design (www.myuptown pooch.com). "They are stunning, and I derive pleasure just from admiring them in her doggie armoires and display cases," says Cindy. Emma Rose has even named a group of designs for this well-dressed pup: "The Precious Dog Collection."

Precious never leaves the house without getting dressed. She is "naked" only in the privacy of her own home, donning T-shirts or casual dresses for quick trips around town or a walk in

available to buyers at the show. The most extravagant of these designs will be appearing soon in a pet store near you. And for those of you who are geographically challenged, in the appendix you'll find the Complete Vendor List from Pet Fashion Week (pp. 135–143) so that you can purchase your favorite items by phone. Consider this your "shop-at-home service" for the dog that will soon have everything.

One dog that has everything—especially when it comes to the latest fashions—is Precious the Toy Poodle, who is the proud possessor of

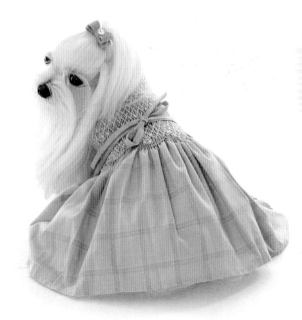

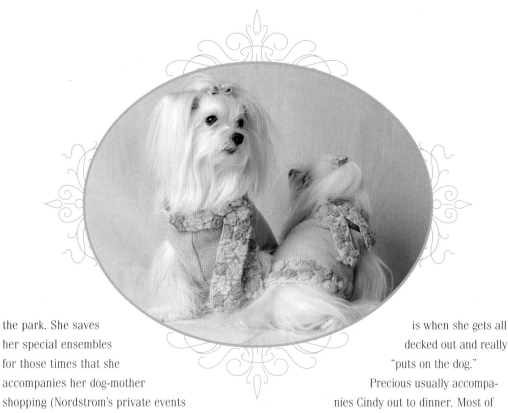

the park. She saves her special ensembles for those times that she accompanies her dog-mother shopping (Nordstrom's private events are a favorite haunt, as is an outdoor mall that welcomes well-behaved dogs). After she gets home, Precious can rest in one of her twenty beds before selecting a new outfit from her display case of gowns to dress for the evening. This is when she gets all decked out and really "puts on the dog."

Precious usually accompanies Cindy out to dinner. Most of the restaurants they patronize have outdoor dining, and Precious is content to sit on Cindy's lap or a chair and eat out of her own porcelain bowl. It is truly a dog's life.

Above: *Oscar Newman Designs*

TRY THIS AT HOME

Your precious pooch can dress in custom-designed ensembles created by your own loving efforts. My recent book *Stylish Knits for Dogs: 36 Projects to Knit in a Weekend* features my own precious pup, Kelly, a Dachshund, on the cover. It has simple instructions for knitting a full array of dog sweaters and matching sweaters and accessories for you, your friends, and your family. I am including instructions here for an easy-to-knit turtleneck sweater for your four-legged companion.

Basic turtleneck sweater. The yarn used in this sample is from Kraemer Yarns Summit Hill.

BASIC TURTLENECK SWEATER

Metric equivalents are given in parentheses in centimeters with 1 inch = 2.5 cm (2.54 cm is rounded off to 2.5 cm).

Needle: size 9
Yarn: 3.5-oz (100 g) ball worsted-weight yarn, 100% super-wash merino wool

FINISHED DIMENSIONS
Size Small
Back: 9 inches (22.5 cm) wide, 10 inches (25 cm) long

Turtleneck: 4 inches (10 cm) long, added to back
Chest: 5 inches (12.5 cm) wide
Sweater Circumference: 14 inches (35 cm)

Size Medium

Back: 12 inches (30 cm) wide, 14 inches (35 cm) long

Turtleneck: 4 inches (10 cm) long, added to back

Chest: 6 inches (15 cm) wide

Sweater Circumference: 18 inches (45 cm)

Size Large

Back: 14 inches (35 cm) wide, 20 inches (50 cm) long

Turtleneck: 4 inches (10 cm) long, added to back

Chest: 8 inches (20 cm) wide

Sweater Circumference: 22 inches (55 cm)

DIRECTIONS

Back

❋ Starting at hem edge, cast on 36 (48, 56) stitches.

❋ Knit two, purl two (2 x 2 rib stitch), for 2 inches (2 inches [5 cm] and 3 inches [7.5 cm]) to form ribbing at hem.

❋ Stockinette stitch (knit right-side rows, purl wrong-side rows) for 8 inches (20 cm) (12 inches [30 cm] and 17 inches [42.5 cm]), for body of sweater.

❋ Knit two, purl two (2 x 2 rib), for 4 inches (10 cm), for turtleneck of sweater.

❋ Cast off in rib stitch, leaving a length of yarn attached to be used to sew together the sweater.

Chest

❋ Starting at hem edge, cast on 20 (24, 32) stitches.

❋ Knit two, purl two (2 x 2 rib), for 2 inches (2 inches [5 cm] and 3 inches [7.5 cm]) to form ribbing at hem.

❋ Stockinette stitch (knit right-side rows, purl wrong-side rows) for 1 inch (2 inches [5 cm] and 3 inches [7.5 cm]).

❋ Decrease one stitch (knit two stitches together) at beginning and end of all, following knit rows until no stitches remain on the needle.

❋ Pull yarn through remaining loop to fasten at point of triangle.

FINISHING

Starting at the turtleneck end of the back, use the attached length of yarn to sew together the ribbed portion to form the neck of the sweater. Do not cut the loose end of yarn when you are done. It will be used to sew the chest to the back of the sweater.

Fit the triangular portion of the chest piece under this turtleneck, and use the remaining yarn to sew one side of the triangular form to the adjoining stockinette-stitch portion of the back piece. Fasten yarn here securely, and conceal end by pulling needle through a few stitches at the reverse side of the garment. Cut yarn.

Use the length of yarn at the top of the triangle to sew the other triangular portion of the chest to the back. Conceal end of yarn as described above and cut off.

Thread a length of matching yarn through your needle, and sew the ribbed portion of the chest piece to the adjoining sides of the back piece, making the chest piece lie flat against the back portion of the sweater. This will leave two openings, one at each side, to accommodate the dog's legs (armholes).

If you wish, you may use a crochet hook to attach a new length of yarn ½ inch (1.25 cm) from the center of the hem. Chain a length approximately 1 inch (2.5 cm) long, and attach other end at the point ½ inch (1.25 cm) from the center on the other side. This will create a loop through which you can pull the dog's tail to secure the sweater to your pet at the hem of the garment.

Good Grrrrooming . . .
You Look Fabulous, Darling!

We can all remember a time when dog grooming meant a bath in a galvanized basin and a quick swipe with a slicker brush. Back in the old days, some lucky Poodles were treated to elaborate hairdos and finished off with toenail polish and a satin bow. Oh, have times changed!

From canine massage to animal aromatherapy, doggie day spas to "pawdicures," the luxury market for pet-grooming products is exploding. Today's pampered pup can choose from potions formulated for every kind of skin type and fur. Lots of pet-product manufacturers have developed extensive product lines to meet the demand of this new grooming classification. And some companies best known for their salon hair-care products have also entered the fur-care industry.

Fur Play

John Paul Pet offers all-natural shampoos and conditioners formulated with an exclusive botanical extract blend. "Pamper, primp, polish, preen" and "Tested on Humans First!" are two of the messages conveyed by its marketing materials, and the company maintains an elaborate Web site, complete with promotional videos, at www.jppetcom. Its product line includes six shampoo formulations—Calming Moisturizing Shampoo, Oatmeal Shampoo, Super Bright Shampoo, Tea Tree Treatment Shampoo, Tearless Gentle Shampoo, and Waterless Foam Shampoo— and three conditioners, Oatmeal Conditioning Rinse, Oatmeal Conditioning Spray, and Smooth Coat Instant Detangling Spray. There are also Full Body & Paw Wipes, Ear & Eye Wipes, and Tooth & Gum Wipes. The array of products seems to rival those offered by the best salon brands of beauty products.

There is a reason for this similarity of offerings, since John Paul Pet was created by John Paul DeJoria, whose face you may recognize from the Paul Mitchell hair-care advertisements and commercials. He was the co-creator of the Paul Mitchell line of luxury salon products and has focused his expertise and love for animals on a new market—pets! And he is not alone in attempting to capture a share of a marketplace that spends more than $43 million annually on pet grooming!

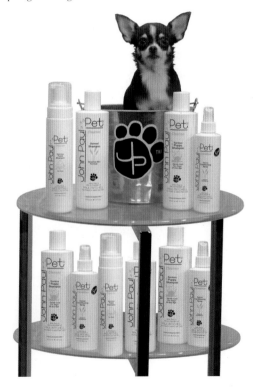

John Paul Pet Products

Just how much luxury is available to dogs today? The Happytails Canine Spa Line offers products guaranteed to "unleash the inner dog." Sparkle and Shine is a brightening and conditioning shampoo, and Comfy Dog is another conditioning shampoo, this one formulated for dry and itchy skin. Calming Aromatherapy Spritzer is their name for a detangling conditioner formulated with lavender and chamomile. Fur Butter (or Fur Worse) is a conditioning treatment for dry, damaged, or long coats. Dry Dog Instant Clean is a spray-on bath replacement, and Fur Breeze,

a spa mist spray, "freshens body and soul between groomings." It is sold in two fragrances: citrus vanilla and rosemary peppermint. (In the olden days, this kind of product was called "doggie deodorizer.") These and other cleverly named products are available from a pet store near you, or you can contact the company at ww.HappytailsSpa.com.

The Spa Experience

But decadence is more than fur-deep. Consider Cain & Able (www.CainAndAbleCollection.com), a manufacturer of spa products for dogs. Its motto is "Every Dog Has His Spa Day." To this end, it produces a complete line of products using all-natural human-grade ingredients and boasts that it tests its products "on humans first." Its Soap-on-a-Rope contains oatmeal, shea butter, aloe, and vitamin E, and is shaped like a bone. ("So mild our staff uses it to wash their faces!" claims their marketing materials.) The company offers Paw Rub, a hand cream for dogs and their

John Paul DeJoria and a satisfied customer

humans; Kissable Combo, a tube of toothpaste packaged with a specially designed toothbrush; and lavender-blend aromatherapy candles, which will relax dogs and their owners during bath time and help to eliminate the wet-dog smell from the room. Their products are sold and used at the most exclusive stores and resorts, including Harrods of London; The Ritz-Carlton; The Benjamin in New York City; the Heavenly Spa at The Westin Hilton Head Island Resort & Spa, South Carolina; Lake Austin Spa Resort in Austin, Texas (ranked the fifth-best spa in the world by *Condé Nast Traveler* magazine); and The Mandarin Oriental in Miami, Florida.

Earthbath (www.earthbath.com) is a line of all-natural grooming products that are "people-tested and pet-approved." It offers shampoos in nine formulations: Mango Tango, Oatmeal & Aloe, Clear Advantages, Orange Peel Oil, Eucalyptus & Peppermint, Tea Tree & Aloe Vera, Hypo-Allergenic, Mediterranean Magic Rosemary Scented, Light Color Coat Brightener, and a Coat Detangler and Conditioner. It also manufactures grooming wipes in two scents, Mango Tango and Green Tea Leaf, to eliminate doggie odor between baths, and Ear Wipes & Eye Wipes, developed to remove "goop, crust, and tear stains."

Bobbi Panter (www.bobbipanter.com) developed a line of natural pet-pampering products for her dog Bobo, who had serious eye surgery to restore her sight. The medications used to treat Bobo during her recovery damaged her skin and fur. Bobbi developed her shampoos and conditioners to restore Bobo's coat and then began to market them to others. The shampoos come in four formulations, Gorgeous Dog, Itchy Dog, Stinky Dog, Bad Hair Day Dog, and a conditioner/detangler called "Snarly Dog." She also sells a spray-on, wipe-off, no-rinse shampoo for those days when there isn't time for the full salon treatment.

On the Scent

No canine spa experience would be complete without the soothing scents of aromatherapy. Pet Aromatics (www.petaromatics.com) is an aromatherapy line developed for dogs. The products include shampoos, conditioners, aromatherapy deodorizing spritz, aromatherapy soybean candles, and dog home candles. Its products come in its six signature scents, Woodsy Woof, Canine Coconut, Dew Drop Doggie, Bow

TRY THIS AT HOME

Want to treat your pup to a little pampering? Try this routine, followed by Precious, our star Poodle, who loves to be groomed. (In fact, the groomer comes to her house, because the little princess won't tolerate being transported in a cage.) Here's a guide to giving your dog the "Precious" treatment.

After lighting relaxing lavender aromatherapy candles, Cindy bathes Precious with High Maintenance Bitch products, designed for both pets and their people. Precious's favorites include Ice Cream Pawlor Tiny Bubbles and Shake Her Bon Bon bath seltzers. (Cindy buys these online from www.thegildedpaw.com.)

Precious especially likes to have her toenails polished. She holds up her paws, one by one, so that Cindy or the groomer can apply the color to her toes. She currently has about twenty-five shades of toenail polish, to match every outfit. (Or should I say, "Pawlish," the name of the pet polish from OPI, available at www.opi.com. Precious also sports hues from Color Paw, available at www.kaboodle.com or www.pretentious pooch.com.)

Finally, Precious recommends that your pampered pup awakens each morning, as she does, to a five-minute dog massage given by Mom. Cindy purchased a DVD on dog massage and follows that instructional routine to provide Precious with an invigorating start to each morning. We should all be so lucky....

CHEAP CHIC

Now every dog can have its day, as companies better known for producing supermarket and chain-store lines of products are also leaping into this lucrative marketplace with popularly priced options—the best for less. Sergeant's, best known for its flea collars, has introduced a line of posh-looking and posh-smelling products at popular prices. Its Ooh la la! collection consists of shampoos, conditioners, brushes, collars and leashes, T-shirts, toys, jeweled hairclips, terry robes, dog training Oui Oui (pronounced *wee wee*) pads, and oh, yes, collars that look suspiciously like the flea collars they began manufacturing in 1868. But these are "fragrance" collars. They can be found at mass-merchant chain stores, supermarkets, drugstores, and pet supply stores near you—or online at www.sergeants.com.

Wow Bouquet, Honeysuckle Hound, and Rose Petal Pooch.

After all this grooming, a dog just wants to add the final touch, a spray of a designer fragrance. Something "strong enough for a man, but made for a Chihuahua," as the marketing for Nature Labs' Cologne for Pets states. The company offers two collections, the Fine and Famous scents, such as Arfmani, DGNY, Dogidoff Cool Dog, and Bone Envy, and the Classic Scents, featuring popular favorites cK-9, Aramutts, Beautifur, Timmy Holedigger, Pucci, White Dalmatians, Bono Sports, and Miss Claybone. You can find a store that carries these fragrances by contacting the Web site www.gotdog.com.

Hot Stuff

After grooming, a posh pup would prefer nothing better than a relaxing nap under a Fauna Sauna. This natural heat source for your pet is extremely therapeutic and can relieve sore muscles and joints. It won the 2006 Editors' Choice Award from *Pet Product News*, which called it "An innovative way to help pets relax and heal through the use of natural heat." You can buy one for

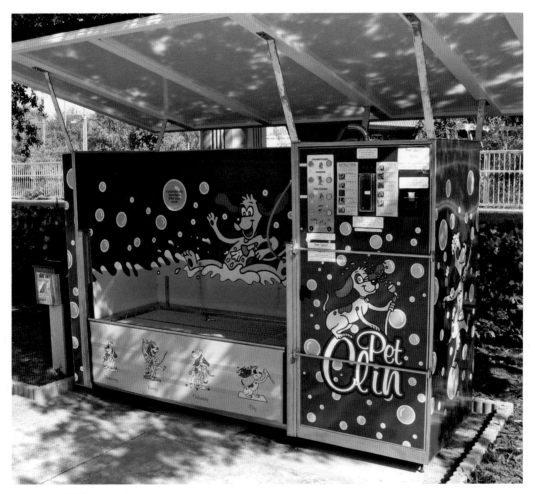

A "car wash" for dogs!

your favorite dog by contacting the company at www.faunasauna.com.

But with our busy schedules, who has time to even give our dogs a bath? That's when you'll wish you had the "do-it-yourself" dog-washing system, Pet Clin. That's right; this handy coin/bill/token-operated device is a virtual car wash, for dogs!

The stainless-steel booth is 8 feet, 5 inches (256 cm) long; 5 feet, 4 inches (160 cm) high; and 3 feet, 3 inches (97 cm) wide; and weighs 880 pounds (2 metric tons). The pet owner places his or her dog on a height-adjustable platform and, by using the handheld nozzle with various pressure settings, showers the pet with a mixture of warm water and all-natural shampoo. After rinsing, the pet owner may dry the pet with a professional grooming dryer. For most pets, the cycle takes about 12 minutes. After each wash cycle is complete, the platform disinfects automatically to prevent the spread of diseases and to maintain the cleanliness of the Pet Clin Booth. Pet Clin can be found at www.petclinusa.com. This device gives a whole new meaning to "drive through"—and is ideal for the busy dog on the go...like yours!

House and Grrrden

Your posh pup wants, and deserves, to live as well as you do. Your dog shares your home, and therefore its environment should reflect your sense of style. Dog beds, houses, home decorative accessories, and even toys have come a long way from the simple and utilitarian designs of years past. Designers and manufacturers are creating sophisticated and innovative choices that will coordinate with every room in your home. Your dog can now express his own unique sense of style with accessories that will fit seamlessly with the décor of any room, any home.

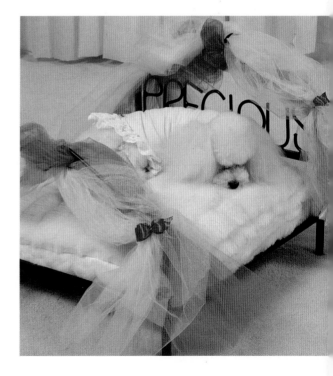

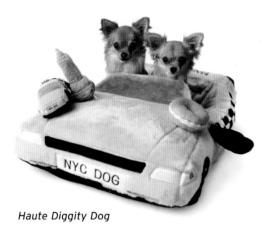

Haute Diggity Dog

Bedtime for Fido

Some pet owners, like Cindy, have a hard time choosing just one dog bed, so Precious the Poodle has twenty dog beds, with one or more in every room.

Owners like Cindy have unlimited options for dog beds. Haute Diggity Dog (www.hautedig gitydog.com) manufactures a line of beds named after pop icons, such as Chewy Vuitton, Chewnel #5, the Furcedes bed, a red Furrari bed, and more. The New York Taxi bed shown here is only one of many clever plush designs.

It also manufactures the sleekly modern, acrylic, invisible collection that includes a clear acrylic bed in a space-age design. A variety of cushions are available, from shaggy fake fur to op art–inspired geometric designs. A matching acrylic feeder contains two dishes suspended in an open oval, as seen here.

Cheengoo (www.cheengoo.com) is an online boutique that sells elegant and minimally designed beds that will coordinate with sleek and modern homes. The Contour Bed is an elegant chaise-like design with stainless-steel legs. Inspired by modernist designers Charles and Ray Eames, the Contour modern dog bed was conceived for dogs of any size, large or small. The Contour's micro-suede reversible cover gives you two beds in one: By simply reversing the covers, you can instantly change the look from a stylish fashion color to a

Haute Diggity Dog

Above and below: *Cheengoo*

more neutral color, and back again. With the Contour series of modern designer dog beds, you can include your dog in your life and your home, without giving up your good taste.

Other stylized beds from Cheengoo include the Vertigo Bed, which looks like a slick sofa upholstered in a pop art stripe-and-dot fabric. It's perfect for any '60s-inspired interior. The popular Sleepy Pod bed is ideal for dogs on the go, as it converts into a handy carrier with just a zip.

Bella Creature Comforts (www.bellacreature comforts.com) developed a line of clever cozy

beds resembling two-tone spirals. Matching mats/blankets are available so that your dog can snuggle up for a good night's sleep under the covers, just like you.

In the Company of Dogs (www.inthe companyofdogs.com) is a catalog of upscale products for dogs. It has a complete

Bella Creature Comforts

Fifi and Romeo

selection of beautifully designed products and currently offers beds shaped like a star from the Hollywood Walk of Fame for doggie divas, a bed that resembles a '60s butterfly chair, a Breezy Bed to provide a spot to nap in the shade, a group of car-seat beds that buckle in for safety, and upholstered beds and mats of every description.

Several other manufacturers offer beds that resemble fine furniture. One example is a Murphy bed from Midnight Pass (www.petmurphy bed.com), made from solid wood in three finishes, natural blond, mahogany, and an ebonized black. The space-saving design folds down and hides a mattress and overhead lights (for reading?!). Another version of a Murphy bed also conceals storage for your pet's clothes, accessories, and feeding bowls. This combination bed/armoire/dining room can be seen at www.thedoggyboudoir.com, www.thepet bedroom.com, and www.purphy.com. Poochie of Beverly Hills (www.poochie ofbeverlyhills.com) offers a line of elaborate upholstered beds with carved wooden legs and plush fabrics.

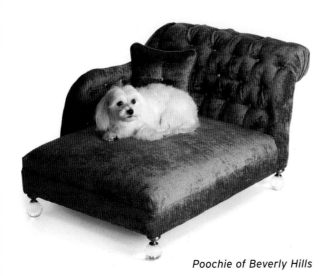

Poochie of Beverly Hills

designs and a clever bed shaped like a paw print are available at Yap Dog Beds (800-900-6600).

Still unsure which bed is right for your precious pup? How about one of these extravagant (and sometimes weird and wonderful) dog beds:

- *Paus* (888-302-7287) makes a fun racecar bed in three sizes and four colors, as well as other fun designs.

- *My Lucky Dog* (www.myluckydog.com) offers plush dog beds in the shape of six different animals. They can also be secured with a car seat, for safe use in your car. Traditional fabric dog bed

- *Spankyville* (540-344-8850) is the manufacturer of a line of painted or naturally stained wooden beds that have great charm and appeal. Their designs include a classic four-poster bed, a ball-post bed, a slat-board bed, a sleigh bed, a colonial design with a matching armoire for your pet's clothes, and a bone-shaped bed.

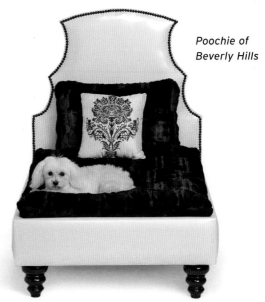

Poochie of Beverly Hills

Poochie of Beverly Hills

- *World Pet* (www.worldpet.com) manufactures elegant upholstered wooden dog beds that look like the furniture in your home. One design resembles a fabric Victorian tent, trimmed with a wooden spire and tassels. Another design looks like a Victorian fainting couch, with tasseled fringe trim and a matching bolster pillow. Another pleasing design is a wicker bed with a headboard and footboard, just like one made for humans.

- *Doggie Hoots* (802-655-1300) designs a full line of pet accessories that are based on cartoon fantasy designs. Its three dog beds include one based on a green peapod, another that resembles a sunflower, and perhaps my favorite, the watermelon bed. They also make matching-fabric chew toys.

- *Auxi Products* (www.auxiproducts.com) manufactures the Empire Series Pet Beds, a full line of metal beds for dogs. Some are ornately worked round bed frames that support a decorative cushion, while others are more elaborate and feature canopy tops.

- Sports fans will be delighted with the athletic line of beds from *HomeTeam Designs* (513-651-PETS), which includes a racecar, soccer ball, basketball, and football. All are constructed of stuffed fabric and are ideal for the family room in your home.

- *Europet Bernina* (www.kandaimports.com) offers a line of dog beds that look like leather upholstered furniture. The designs include a dog couch, one that resembles an overstuffed chair, and another that looks like an ottoman.

- *Brockseptember Design House* (www.brock september.com) makes a personalized wooden dog bed out of vintage recycled oak wine barrels. These are stenciled with your dog's name or monogram and are fitted with a pretty fabric cushion.

- Two Web sites for sporting dogs are www.llbean.com and www.orvis.com. These companies offer an array of rugged designs like Bean's Rugged Good Pet Bed, which has Sherpa lining and is inspired by their comfy slippers of the same name. And be sure to check out the adorable canoe-shaped bed available at Orvis.

- *Dog Gone Smart Beds* (www.doggone smartbed.com) are made from a special fabric that uses nanotechnology to stay clean and dry. They stay clean and kill bacteria naturally, so they're perfect for the "dirty dogs" among us. The designs are simple and appealing in solid colors, some ornamented with contrast piping.

CHEW ON THIS
Sleep on It

Does your dog have special sleep needs? Orthopedic beds are available for dogs that require additional support, heat, or cooling. These come from SSS PetCare Coil Spring beds (www.petgoodsmfg.com); K & H Manufacturing (www.khmfg.com), which offers a complete selection of heated and cooled dog products, as well as memory foam products; Buddy Beds (www.buddybeds.com), featuring comfy memory foam beds for your pooch; and Dolce Vita (www.dolcevitapets.com), which sells an impressive array of heated and cooled beds, mats, and car-seat covers.

Dogged Designers and Artists Create Dog Beds

Renowned designers of furniture and other products for people are developing designs for dogs. Jonathan Adler (www.jonathanadler.com), who is known for his ironic, retro-pop aesthetic, is creating dog mattress covers in his signature fabric prints. (The mattresses are sold separately.) McRoskey Mattress Co. (www.mcroskey.com) creates custom mattresses. And well-known furniture designer Mitchell Gold (www.mitchell gold.com) is now offering dog beds.

Artists are also putting their hand to pet-product design. William Wegman, the famed photographer who captures his Weimaraners dressed in an array of costumes, has designed a line of performance fabric beds and accessories for Crypton Super Fabrics. The fabrics resist stains, odor, moisture, and bacteria without compromising style or design. You can see the collection at www.cryptonfabric.com.

Stephen Huneck (www.huneck.com or www.dogmt.com), an artist known for painted wood-carved sculptures of dogs and an author of illustrated books, has created a line of pet products. These consist of home accessories and furniture, pet accessories, and dog toys and gifts. The line has been successfully sold at both In the Company of Dogs and Orvis, and will now be available at stores near you. Products include a dog toy chest, a wall-hung leash holder, feeding mats, feeding stations, biscuit jars, dog dishes, bandanas, toys in fabric and rubber, and turkey leg treats.

In the Doghouse

Sure, a deluxe dog bed is fine for some dogs. But perhaps your darling doggie requires an entire abode of his own. Why not spoil your pooch with a luxurious doghouse? Bow Wow House (www.bow-wowhouse.com) manufactures a full line of doghouses and ornamented crates. Dog crate designs include spirals, banana leaves, bamboo leaves, and daisies. Doghouses include a log cabin, a garden cottage with flowers painted on the sides, a gingerbread house, a Polynesian hut (called "Tiki Hut"), a South Beach beach house, and a harlequin-patterned doghouse.

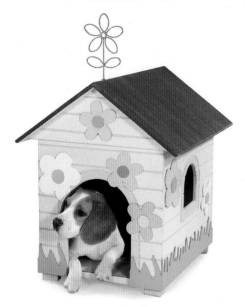

Bow-Wow House

TRY THIS AT HOME

Merry Products (www.merryproducts.com) offers a collection of wooden doghouses, such as Bed and Breakfast, Ice Cream House, Room With A View, Bungalow, Stable, Boat House, and Log Cabin and Chalet designs. These whimsical designs are the height of doggie luxury!

Finally, if you choose to share your bed with your dog, he might need a set of pet stairs to get in and out during the night. A wooden set that looks like furniture is available from www.mrherzher.com. Furry fabric-covered stairs can be found at www.pwtstairz.com.

You love your pooch with all your heart, right? You can remind him of this all through the night with the ultimate doggie bed, the Pillow With a Heart Pet Bed (www.terrificpets.com/pet_supplies/ dog/beds/pillow/15338.asp). Tucked deep inside this unique dog bed is a heart that beats to soothe your dog to sleep. Breeders and trainers often recommend that you tuck a ticking clock into your pet's bed to remind him of his mother's heartbeat in the womb. This bed replicates the sound of a heartbeat to provide comfort and to prevent separation anxiety. They are priced from $50 to $130, depending upon size. However, if you can't afford this designer bed, any clock will do, as long as it ticks—just remember to turn off the alarm! We know you'll want one for your dog in a heartbeat....

You Are What You Eat

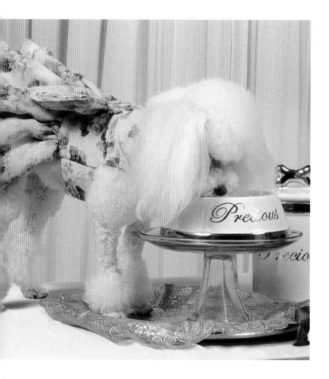

We all want to treat our pets to the best foods, and for some of us, that means cooking meals for our dogs. Precious the Toy Poodle will turn up her nose at filet mignon if it's not cut up into tiny pieces, and will only eat canned food if she is fed with her little pink baby spoon. Precious loves chicken, and kibble, especially when her owner, Cindy, grates a little bit of sausage over the top. Other favorites include lettuce with her "Grandma's" homemade Roquefort dressing, and rye bread with peanut butter.

Lots of good recipes abound in dog cookbooks (www.amazon.com lists 236 cookbooks for dogs, while www.barnesandnoble.com tops this with 297 titles) and on the Web (www.thepoop.com, www.epicurious.com, www.allrecipes.com, and www.recipezaar are just a few sites that list dog food and treat recipes). One other Web site,

www.BalanceIT.com, provides pet owners with free pet food recipes custom-tailored to their choice of ingredients. While some of us may choose to prepare meals for our pets from scratch, veterinarians caution that homemade foods might be lacking in nutrients necessary for our dog's health. They recommend that you feed your dog any of the prepared foods sold in stores. All foods sold must meet nutritional standards set by the government, and prepared foods may be one of the best places to find complete nutrition for your pup. Apparently most dog owners in the United States agree with this notion, since they spent more than $8 billion on dog food in 2006.

Celebrity-Inspired Cuisine

Big dollars translates into big names. Some high-profile celebrities have become involved in the marketing of dog foods. For example, Lassie, perhaps the world's best-known and beloved dog, appears on every package of Natural Way Dog Food.

Lassie, who was the star of eleven feature films and 691 television episodes, is one of the most recognizable names and faces in entertainment. The TV program ran for twenty years and was one of the longest-running series in television history, seen in more than 100 countries around the world. It was also the winner of two Emmy Awards. Since its debut in 1938 as the subject of a short story written by Eric Knight, Lassie has become a worldwide star on account of her heroic instincts, nurturing disposition, and love of family.

It is for these reasons that Lassie is the "spokesdog" for her own line of dry dog foods. The all-natural foods are made in three formulations—Puppy, Adult, and Senior—and come in two flavors, Lamb Meal and Rice, and Chicken Meal and Rice. Crunchy biscuits, jerky strips, and training treats complete the assortment. The foods are available at a supermarket near you, or you can contact the company at www.lassie.com.

The actor Dick Van Patten is also involved in pet nutrition. His food is called Dick Van Patten's Natural Balance Pet Foods. This line includes Eatables, the only canned dog food made not in a pet-food plant, but in a USDA plant that makes food for humans. The food contains a mixture of fresh meats and vegetables, as well as other premium ingredients, and is

balanced to provide all the nutrients, vitamins, and minerals necessary for puppies through adulthood. The five varieties are Irish Stew, Chinese Take-Out, Hobo Chili, Southern Style Dumplin's with Gravy, and Spaghetti with Beef in Meat Sauce. The company can be contacted at www.naturalbalanceinc.com.

Another well-known marketing franchise is the popular and bestselling series of books *Chicken Soup for the _____ Soul.* This series now transcends books and has moved into marketing. The newest entry is a brand of pet food called "Chicken Soup for the Dog Lover's Soul." The natural and holistic foods include formulas for dogs of varying sizes and ages, in both dry and canned versions. They also produce a line of wheat-free biscuits in five varieties, including Arthrocare, for arthritic dogs. You can find the company at www.chicken soupforthepetloverssoul.com.

Confucius says, "There will be Chinese food in your future...."

Barking Gardens & Cookie Co.

Natural Eats for Healthy Hounds

Eagle Pack (www.eaglepack.com) offers Holistic Select foods, which are made from USDA meats; carrots and peas; apples, blueberries and cranberries; whole grains; fats; eggs; alfalfa; fiber from beets and tomatoes; kelp; and yucca. The foods are available in dry and canned formulations, as well as in vitamin and mineral supplements, which can be added to your dog's food.

Tripett is a food made from "green" (pure and unbleached) tripe from human-grade food sources. Tripe contains the partially digested grasses in an animal's stomach, and is rich in digestive enzymes, gastric juices, taurine (an amino acid), other amino acids, and essential fatty acids. (Yum!) The foods use no preservatives or additives, and claim to provide your dog with cleaner teeth, a better digestive system, healthy skin and a healthy coat, and improved eating habits. This veritable fountain of youth for dogs can be found at www.tripett.com.

Eukanuba (www.eukanuba.com) is a food brand known to most every person who has a dog. What you may *not* know is that the company has now formulated four custom care diets: Sensitive Skin, Weight Loss, Sensitive Stomach, and Healthy Joints. It has also created five new breed-specific diets: Labrador Retriever, Yorkshire Terrier, German Shepherd, Dachshund, and Boxer. These are five of the ten most-popular breeds in the United States, so the foods should take a bite out of sales of the more generic varieties offered by most other companies.

Bravo (www.bravorawdiet.com) advocates a raw-food diet for your dog. The company has formulated its foods from human-grade, USDA-approved, and antibiotic-free meats; uncooked bones; organ meats; and vegetables. The foods are rich in vitamins, minerals, enzymes, and amino acids, because they are not processed with heat. There are no grains, fillers, preservatives, or additives of any kind. Varieties offered include Chicken, Turkey, Beef, Lamb, and Pork in blends, burgers, basic and boneless, and bites. Specialty meats like Buffalo Liver, Venison Liver, Turkey Hearts, Salmon, and Cod are also available.

Canine Caviar (www.caninecaviar.com) is the delightful name for a line of holistic dog foods. While there is no actual caviar in evidence in any of the varieties, these wheat-and-gluten-free foods come in Turkey, Duck, and Beaver flavors.

Remember how your mother always told you to eat your vegetables? Now you can say the same thing to your own furry baby. Pegetables (www.pegetables.com) are adorable vegetable-shaped chew treats made of vegetables! They are shaped like corn, carrots, and celery, and are fun to eat and good for your pup.

Sweet treats

For the Gourmet Palate

Doggie Vita has prepared a line of fully cooked Italian pasta meals for dogs. The flavors include Lasagna with Wild Boar Meat, Fusilli Pasta with Salmon, Rigatoni Pasta with Grouper, Cannelloni Pasta with Venison Meat, Mezzaluna Pasta with Hare Ragout Sauce, and, for vegetarian dogs, Cheese Tortellini Pasta with Walnuts. These 100 percent natural meals are prepared from human-quality ingredients with no preservatives, artificial colors, or salt. They are vacuum-packed for a shelf life of up to eighteen months without refrigeration, and look good enough to eat! The company also offers nutritional drinks for dogs. For more information on either of these products, contact Mike.Kelly@ doggievita.com.

Merrick Pet Care (www.merrickpet care.com) offers a full selection of enticing gourmet food choices for your dog. Gourmet canned entrées include Grammy's Pot Pie, Brauts-n-Tots, French Country Café, New Zealand Summer, Rocky Mountain Rainbows, Cowboy Cookout, Mediterranean Banquet, Smothered Comfort, Thanksgiving Day Dinner, Turducken, Venison Holiday Stew, Wild Buffalo Grill, Wilderness Blend, Wingaling, Puppy Plate, Senior Medley, and Working Dog Stew. Plated up, these foods look good enough to serve to your whole family (although you probably won't...). Dry foods are available in many of the same flavors. The company's treats include real meat sausages and other delicacies in equally fun flavors and forms.

For dogs that are finicky eaters, you might try adding Real Food Toppers (www.realfoodtoppers.com) to their regular food. These come in eight flavors: All American (steak and potatoes), Holiday (turkey and cranberries), Country Pot Pie (chicken, peas, and carrots), Fish 'n' Chips (cod and potatoes), Chicken Breast, Wild Salmon, Beef Sirloin, and Beef Liver. These are freeze-dried, human-grade foods, with no artificial ingredients.

A spot of tea

Sniffers Shake-Ins is another flavor-enhancing food topper, this one in dried, shake-on form. It comes in three flavors: Chicken, Roasted Beef, and Liver, and can be ordered from Chomp at www.chompinc.com.

What better way is there to start Sunday morning than to have bagels for brunch? Now you can share the experience with your dog! Dog House Natural Bagel Treats and Puppy O's Mini Bagel Treats are a fun way to nosh with your dog. These treats are courtesy of Bagel House (847-726-6060), a company that has made bagels for people since 1925, using a family recipe brought back from Russia.

Happy Endings

If you eat all your dinner, you will get dessert. Now your dog will have something to look forward to, since there are many delicious ways to end a meal. Cookies and cakes are available from more than 800 doggie bakeries in the United States and abroad. You can find a bakery near you on the Internet (there are more than fifty pages of listings on Google), or you can order them from Pawsitively Gourmet (www.pawsitivelygourmet.com),

Claudia's Canine Cuisine (www.claudiascanine cuisine.com), Foppers Gourmet Pet Bakery (www.foppers.com), or from the bakery that started it all in 1989 in Kansas City, Missouri, Three Dog Bakery (www.threedog.com).

Bark Bars are packaged like candy bars, with a bright-colored paper wrapping. They are natural cookie bar treats for dogs and come in four flavors: Carob, Peanut Butter, Peanut Butter & Carob Chip, and Honey & Oats. These and lots of other fun cookie treats are available from American Health Kennels (www.american healthkennels.com).

Ice Cream is another delicious way to end your meal. I.C. Spots Sundae Treat for Dogs is far healthier than it sounds. Tested at the University of Wisconsin Veterinary Hospital, it is fortified with vitamins and minerals, and contains the essential fats that dogs need for a shiny coat and healthy skin. The sundae is lactose-free and high in soy protein and contains glucosamine, which promotes healthy joints. One 3-fl.-oz. (100-ml) sundae cup has the nutritional content of one-half cup of standard dry dog food. I.C. Spots is available in two dog-pleasing flavors: Beef and Peanut Butter Swirl. You can find a store near you by contacting www.icspots.com.

Barkday cakes

What meal is complete without an after-dinner mint? Your dog could certainly use a little breath freshening after a meal. Fido's Mints for Dogs (www.fidoscookies.net) are packaged in an adorable little bone-shaped tin, and they even have a version for people, so you can share the freshening experience. Your dog will be glad that you did!

Pawcelain Dishes

Precious the Poodle would not eat off a plastic dog dish, and why should she? Many restaurants in her hometown feature outdoor dining, so Precious often accompanies Cindy to dinner with friends, and eats out of a bone china bowl personalized with her name embossed in 24-karat gold. Posh pups like to dine in style, and lots of companies have designed beautiful dinnerware to set the table (or floor...) in a grand manner. There are designs to fit every décor and taste level, from bright to elegant, minimal, and sporty. The choice is yours and your four-legged friend's. The following are some of the more unusual options I've found.

Castlemere (at www.castlemere.com) is a company that devotes itself to beautiful, upscale dinnerware for pets. The company's dog dish designs are wonderfully imaginative, with styles that will please any aesthetic. Highlights include Houndstooth, Paisley, Sweetie Pie, Daisy Dots, and Dotted Swiss. They have a "Teacup" collection for toy dog breeds, and their Glamour Pets collection will suit any doggie diva. Feeders and mats complete the extensive line.

Pet Goods (www.petgoodsmfg.com) offers designs in wood, plastic, metal, and wicker. Their designs are opulent and well thought out; some even feature a hidden drawer to hold dry food. The company also has the license for NASCAR-licensed designs and offers an extensive collection of these products.

Up Country (www.upcountryinc.com) has a full array of pet accessories, but their dishes and mats are very special. Collections include Wave, Nautical, Blue Dot, Cool Dog, Squiggle, Green Floral, Pink and Green Stripe, Dog Bones, and Flower Power. It even offers Jingle Bowls for the festive holiday season.

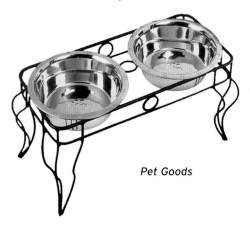

Pet Goods

A fun collection of plastic dinnerware is manufactured by Cats Rule/Dogs Rock (www.catsrule.com). It offers a full line of sleekly modern dishes, mats, and feeders in sophisticated patterns, like Zebra and Tortoise Shell, and in solid colors, such as pastels, black, and silver.

Petsy (www.itspetsy.com) manufactures the Lunar Bowl. This smartly designed pet bowl has a night light in the base, for midnight snacking. It also uses disposable liners, to ensure a clean and fresh bowl every time.

Speed eaters can be slowed down by specially designed bowls from Alpha Paw (www.alphapaw.com) and Brake-fast (www.brake-fast.net). These patented designs feature baffles, which prevent your dog from wolfing down its food, which can result in digestive distress and more serious problems like bloating.

CHEW ON THIS
His Master's Voice

The most innovative way to communicate with your dog while you are away is via the Chatterbowl (www.chatterbowl.com), a talking pet bowl. The bowl, which retails for $24.95, is equipped with a device that will record a ten-second message like "Be a good dog today, Phydeaux." Every time your dog eats or drinks from the bowl, the message will replay in your own voice. This should keep your dog company, and reinforce his obedience training throughout the day. "Good dog!"

Fitness for Fido

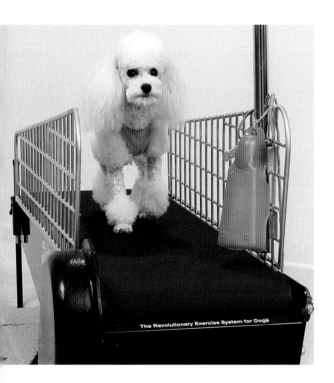

Today's posh pup is often carried from place to place by his owner in a clever travel bag. Much like today's modern children, a dog without adequate exercise will become overweight, and may suffer the health consequences of obesity. What is a pudgy pup to do?

You might begin by taking your dog out for regular walks, on his own four feet, rather than carrying him along while you walk. In this way, you can both reap the benefits of a workout done together. Many communities sponsor dedicated dog runs, or dog parks, where well-behaved animals can play off-leash and interact with each other. Check with your local parks authority to see if there is one near you.

Busy dog parents in cities often hire professional dog walkers to take their dog out for exercise during the day. You can locate one of these

services by asking friends who have dogs or by consulting with your veterinarian. Other sources for information are local pet stores, groomers, humane societies, and even the doormen of nearby apartment buildings who often see these pet professionals on a daily basis.

Doggie Daycare

Many indulgent owners are enrolling their animals in doggie daycare programs. These facilities often have dog runs, where the members can engage in active play with the other dogs at the facility. Some facilities offer one-on-one play time with caregivers, so your dog will return home happily fatigued after a day of exercise and social interaction with people and other dogs. Other daycare facilities even offer supervised workouts on specialized exercise equipment, like treadmills designed for dogs. Many are equipped with closed-circuit cameras that are linked to the Internet, so that you can view your dog and his activities from your computer at work!

You can locate a daycare center near your home by asking friends who have dogs or by

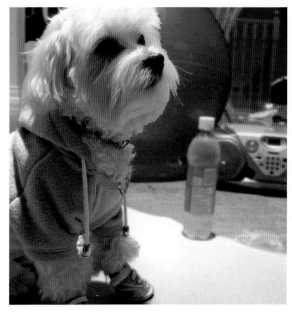

Work up a sweat.

inquiring with or consulting the bulletin boards of veterinarians, groomers, and pet stores. Your local magazines and newspapers may also carry ads for these facilities and services. In all cases, you can also consult the Internet to find reliable pet resources. Some large pet-store chains, like PetSmart, are beginning to offer doggie daycare facilities within their stores.

Dog Runners

You may be familiar with dog walkers, people who come to your home while you are away at work to walk your dog for exercise and companionship. This used to be the epitome of indulged-dog activity, hiring someone else to walk your dog.... Well, savvy pet owners in major cities like New York, L.A., and San Francisco have taken that concept to the next level. They have begun to hire *dog runners*, personal trainers for dogs.

The dog runner comes to your home, and for a fee that might range from $28 to $40 per run, takes your dog out for a thirty to forty-five minute run (depending upon your dog's age, breed, condition, and level of stamina). Seth Chodosh, founder of Running Paws in Manhattan, serves 150 clients per week. Another New York service is www.nyc dogrunners.com. You can locate a dog runner near you by asking your veterinarian or friends who have dogs. Athletic high school or college students are another potential source for dog runners in your community.

Gym Dogs

You can add a doggie gym to your home with the purchase of a treadmill. Jog A Dog (www.jogadog.com) offers professional-quality treadmills designed especially for dogs. These treadmills are used in the exercise center of The Westminster Dog Show and are available in four different sizes: Small (for all toy breeds), Medium (for dogs that are medium size or smaller), Large (for any-size dog), or Extra Large (with room for larger breeds to reach and extend their legs during exercise). If you have several dogs, it is best to purchase the size appropriate for the largest dog, because smaller dogs can be exercised on any of the larger machines. The prices range from $1,095 to $2,995.

Another piece of equipment for your gym is the Therapy for Dogs Underwater Therapy System (www.therapyfordogs.com). This device is for hydrotherapy, and it includes a waterproof treadmill positioned within a stainless-steel and tempered-glass tank. The heated water provides hydrotherapy for your dog as he exercises on the treadmill.

If you would like to gauge the mileage clocked by your dog, you can put a dog pedometer on his collar. This simple and lightweight device is shaped like a dog bone or a paw print, and it records every step or exercise minute your dog takes throughout the day. Its one-touch display gives you an automatic reading. This is one way to find out how much activity your dog is experiencing while you are away during the day, and it is also a good way to gauge how much exercise he has had during your walks together. You can learn more about such devices at www.dogpedometer.com, www.walkingwithattitude.com, or www.midnight pass.com.

Lap It Up

Swimming is another exercise that is fun to share with your dog. Although most country clubs and public community pools may frown upon bringing your dog along for a dip, you can share a pool at home with your best friend. This can range from the most elaborate in-ground home pool—if price is no object—to an adorable bone-shaped wading pool that is more appropriate for smaller dogs. The Bone Pool is available at www.onedogonebone.com.

Those opting for larger pools might wish to add special stairs so that their dogs can climb out with ease. Pool Pup (www.poolpup.com) manufactures an easy-to-install, adhesive-attached set of pool stairs for small dogs. Skamper Ramp (www.skamper-ramp.com) offers an easy-to-assemble pool ramp in two sizes, one for dogs up to 45 pounds and the other for dogs over 45 pounds.

Poolside pups should seek shelter under a Petbrella (www.molor.com), which includes a tie-out stake for your pet's leash and a cloth sun umbrella. Don't forget your Hawaiian bikini or swim trunks. Cocojor (www.cocojorhawaii.com), a pet-products manufacturer from Hawaii, makes a complete line of swimwear, including bikinis, miniskirts, one-piece swimsuits, Loco Moco Shorts, Kukui Speedos, and even Surfer Board Shorts! If things get too hot, they also offer Hawaiian Sun Cooling Products that have cooling crystals sewn into the layers of cloth. Items include bandanas, sun caps, vests, and tops, and for the ultimate sun worshipper, a

Sun Cooling Mat. Or, your pooch can cool down with a hydrating sports drink, like Cool Dog (www.animalbizconcepts.com) or Hydro Dog Sport Water (www.hydrodog.com).

Boating with your dog is another way that you can spend time with your pup. The more chic among us may choose to book passage on the Cunard Line Queen Mary, which maintains a kennel for dogs that wish to make the transatlantic crossing with their people. Others may have their sights on smaller vessels. We recommend that you take along a doggie life jacket, in case of "dog overboard." Several companies carry them, including Paws Aboard (www.pawsaboard.com), which also has a doggie boat ladder; Ruffwear (www.ruffwear.com), which carries all forms of high-performance wear for active outdoor dogs; and Doggles (866-DOGGLES), which carries protective eyewear goggles for dogs and lots of other gear, including doggie backpacks.

The Grrrreat Outdoors

The more rugged dogs among us will prefer hunting, fishing, and camping to more urban pursuits. These dogs will like the high-tech look

Gun dog in canine camo

of outdoor sports gear from Hyper Products (www.hyper-products.com). Its innovative and well-designed equipment includes Ball Launchers, which will catapult two to four tennis balls, and are designed for hands-free pickup, so slobbery, muddy balls are no longer an obstacle to play. It also offers a simple device called "Tennis Dog," which will launch a single ball at a time. Retrieving dummies, used to train hunting dogs, can also be shot out by means of a Dummy Launcher. Fido Footballs are dog-size, with a convenient handle for throwing, and playing tug-of-war. It also offers soccer balls in three sizes, so that every dog can be engaged in regulation-style play. Its cleverly conceived Doggie Driver combines a good game of fetch-

the-tennis-ball with the swing skills required on the golf course. The company's macho chew toys are shaped like carpentry tools (such as a hammer, wrench, chisel, and file), and it even offers a Cleanup Claw, a hands-free cleanup system that stores fifteen bags in its handle.

Remington, known for its rifles and shotguns, has licensed its name for a line of accessories for sporting dogs. The company offers a full range of collars, leads, and harnesses; training dummies and kits; a field-training bag to contain all these goodies; safety vests in hunter's orange and camouflage; and rugged toys, including a plush shotgun shell, a plush shooting clay disk, a duck, a bone, and a camouflage-patterned hunting boot. You can find these items and more at www.coastalpet.com.

Dance to the Music

If you would like to try a new form of exercise with your dog, and you enjoy music and dancing, Canine Freestyle is for you. The Canine Freestyle Federation Web site describes it as "a choreographed performance organized with music, illustrating the training and joyful relationship of a

CHEAP CHIC

Don't have the cash for a personal dog trainer or a high-priced pool? Organized exercise is another way for you to spend invigorating time with your pup. You can design an exercise program for your dog by allocating from fifteen minutes to one hour daily to shared activities like walks, running, and, for larger dogs, biking with your dog running alongside the bicycle. Other options include fetch, Frisbee, soccer, swimming, agility training, and even exercise at night using a collar that lights up, so you can see your pet clearly. You will find these activities to be a great benefit to both of you, in bonding, calories expended, and just plain fun!

CHEW ON THIS

Dog-ercise

There are a great number of books that show ways to exercise your pet. A quick Web search of "dog fitness" reveals hundreds of titles available at online book retailers. These are some of the most popular titles.

- *Fitness Unleashed* by Marty Becker, D.V.M., and Robert Kushner
- *Healthy Dog* by Arden Moore
- *Fat Dog Thin* by David Alderton
- *Fitness Planner for Your Dog* by Linda Waniorek
- *The Simple Guide to Getting Active with Your Dog* by Margaret H. Bonham
- *Running With Your Dog* by John A. Sanford
- *Doga: Yoga for Dogs* by Jennifer Brilliant and William Berloni
- *Bow Wow Yoga* by Gerry Greengrass

You can find these titles and more, wherever you shop for books.

dog-and-handler team." This activity presents a way for you both to dance the calories away! You can learn more about this and locate a group near you by contacting the Canine Freestyle Federation at www.canine-freestyle.org.

Playing Around

Many dogs get their exercise from playing with their toys. Today's dog toys have come a long way from the old tennis ball or plastic bone. The indulged dog prefers a stuffed plush toy that reflects its taste in fashion, cuisine, collectables, sports, and so forth.

Haute Diggity Dog (www.hautediggity dog.com) is the manufacturer of a full line of sophisticated plush chew toys, such as those shown here. The company is known for its

Luxe Logos

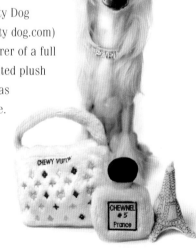

Sushi and Doggie Rolls

designer interpretations of well-known fashions, including the monogram bags and perfume bottles also seen in the photos.

Precious the Toy Poodle, whose photograph appears at the beginning of this chapter, has too many toys (as does her dog mother, Cindy), but her favorite, says Cindy, is "a big furry round dot that looks like road kill when it gets wet." Fetch is her favorite game, especially at parties. According to Cindy, "She insists on being the center of attention at all times. She will pick out

TRY THIS AT HOME

To exercise your dog at home, try running around inside your house. Your dog will follow. This works best where there are stairs, or lots of rooms. Alternatively, for those of you more into spectator than participatory sports, you can always play a game of fetch by tossing toys for Phydeaux to chase, all from the comfort of your couch or bed!

the one person who is talking at a party and drop a toy at his feet or in his lap, and then step back a few feet and wag her tail, bat her eyes, and beam at that person until he throws her toy. She's quite the little flirt...."

Armchair Athletes

If all this mention of activity makes your pup want to curl up and take a nap, perhaps the closest he will come to being a sporting dog is dressing like one. For those pups more into spectator sports, you can choose from officially licensed and authentic jerseys, hats, collars and leashes, bones, and Frisbees from the NFL, Major League Baseball, NBA, NHL, Collegiate Teams, WNBA, and NASCAR. Your pooch can dress like the players on your favorite team, while you both watch the tube and cheer them on from the comfort of your own couch! These products can be ordered from www.huntermfg.com. Pass the chips....

Sit. Stay.

Today's savvy pet knows that in order to accompany its owner everywhere, it must learn to obey the rules. Sit. Stay. Good dog! Many first-time pet owners take for granted that their adorable furry bundle of joy will remain a joy forever. While this sentiment may be true for most new puppies, the delightful little balls of fur have the annoying habit of growing up.

They get larger, and grow more active. Before long, they are cutting their first teeth, and like any baby, this causes discomfort that can be alleviated by teething. Unlike their human counterparts, however, the puppy's teeth are pointy and sharp. They can cause pain and damage if they chew upon one of your body parts, or upon items that you would prefer not to customize with their teeth marks. Forbidden items might include all

Only the best shoes to chew on

apparently harmless gesture will have far-reaching consequences. How is a tiny puppy to know that the beat-up old shoe is the only one it can chew on? The puppy is unable to differentiate between the mauled moccasin and your magnificent new Manolos. It might seem that the roles are reversed—that it is the *person* who requires training, not the dog. In fact, this is the position taken by many professional dog trainers.

Home Schooling

Some new pet owners might choose to connect with a professional by means of a book, tape, or CD that provides the rudiments of his or her method for taming a dog. You can go to any bookstore, pet store, or even online to obtain countless volumes that will show you how to educate your animal to obey simple commands. Indeed, most trainers first like to teach the dog to sit and stay, since the animal can be deterred from causing any damage to itself, property, or others by simply sitting down and remaining seated. Immobilization is the first defense.

forms of footwear, clothing of every description, furniture legs, rugs and upholstery, objects left unattended on a surface or floor—just about anything that can come into contact with their inquisitive little mouths.

Inexperienced pet owners might be helpless to prevent the onslaught of damage. Indeed, some innocent pup parents might throw the dog an old shoe to chew on, without realizing that this

Some pet owners find themselves challenged in their efforts to understand the rules

and impart them to their young four-legged charges. The puppy interprets this as a loss of control. The roles become reversed as the small dog assumes the position of alpha dog. Pup in charge.... It is in these cases that a professional trainer should be brought into the picture.

Sit. Stay.

The Dog Whisperer

Enter the animal behaviorist—a live, on-site presence, who can take the situation in hand and untangle all the mistakes you made while breaking in your puppy. I know all about this, because I have been there.

Once upon a time, I, too, was a new pup parent. I was the proud possessor of a tiny ball of white fur named Morgan. He was a West Highland White Terrier, more commonly known as a "Westie." And he was adorable. Everything he did was cute. I could spend hours marveling over his every gesture and move.

But one day, he began to chew. First it was toys, but before long he graduated to everything he could find on the floor. I became compulsively clean. I felt like I had OCD (obsessive-compulsive disorder). Everything was put away in its place. But this didn't stop Morgan.

He moved on to the wooden floor molding, and from there, to the plaster walls. My fluffy white dog developed a taste for plaster. At first I didn't see this, because his white fur concealed the white dust formed by his teeth grating against the wall. But before long, I noticed an

ever-increasing hole in the wall of my apartment that was adjacent to the lobby of the building. Morgan had befriended the doorman, and it seemed as if my little pooch was building an escape route to join his crony on the "outside"!

At first I found it cute. I pointed the hole out to visitors and remarked brightly that Morgan was digging a hole to China. I tried taping over the hole, thinking that he would outgrow the habit, and I could then hire someone to replaster the wall. But, alas, Morgan continued in his quest for freedom.

I confided my plight to the owner of an upscale pet boutique, and she told me that she was forming a class for puppies to be taught by a friend who was good with dogs. I signed us up immediately.

The first evening of class, I showed up with my squirming white puppy. We were surrounded by an array of dogs of every size and description. Then the instructor came in. At least I thought he was the instructor. A chubby young man with a mop of brown hair and an infectious smile looked around the room. He began to talk. And the dogs began to listen.

It soon became evident that he had a gift for communication that none of us possessed.

He could instinctually interact with our puppies. "Sit," we said, and they didn't. "Sit," he said, and they did. The young man assured us that after the series of lessons were done, our dogs would obey our commands as readily as they were obeying his.

The instructor told us to call him Bash, which was short for Bashkim. His last name was Dibra. This was a strange and magical name for someone who seemed to possess an otherworldly connection to our dogs. And true to his promise, at the end of the "semester," Morgan and the others had transformed into the kind of dog we had hoped they would be. I was able to repair the wall, and Morgan's behavior was exemplary. But that was all a long time ago....

Bash, the Sequel...

Fast-forward the film of memory to a year or two later. Morgan and his new Scottish Terrier "sister" Nubie were the dog stars of their neighborhood. They inspired me to start a business that created designer-quality clothing and accessories for pets.

Back in the eighties, dogs wore boring acrylic turtleneck sweaters to protect them from

the cold. I had begun to dress my dogs in imaginative and creative hand-knit sweaters that resembled the ones I wore myself. People stopped me on the street to ask where I bought their clothes. Some were handmade, and others came from stores in Europe where I had shopped while traveling. I realized that there was a demand for special things that was not being satisfied by the pet-product industry, so I started a company that I called Dogwear.

I created a press piece called *Dogwear Daily*, a take-off on the fashion newspaper *Women's Wear Daily*, to publicize my line, and eventually that newsletter morphed into an idea for a fashion magazine for pets. But I only had two dogs. I would need more models for the look I envisioned. So, I called my friend Bash, to see if he could help me find and work with the dogs. And he could. And we did. The rest is pet fashion history. *Dogue*, the first pet-fashion magazine parody of *Vogue* magazine, was born.

I went on to create a sequel, called *Catmopolitan*, a dead ringer for *Cosmopolitan* magazine, only mine featured articles for and about cats. Bash was my animal talent agency and my animal handler on photo shoots. And, as with the pups, his relationship with the cats was magical. I had never seen cats so attentive and obedient. What was his secret?

Bash told me a story about his childhood in Albania. He was three years old when his family fled the country to Yugoslavia, but they were imprisoned in a refugee camp that was guarded by wolves. He was able to befriend the wild animals, and before long, they were literally eating out of his hands. He learned that he had a gift for communicating with animals, and knew as a young child that his career would build upon this skill.

Bash trained under a number of master animal trainers as his family traveled through Europe on its way to the United States. The family eventually found itself in New York, and that is where he began to train animals professionally.

He called upon his early skill with wolves when he located and trained a young timber wolf he named Mariah to star in an ABC after-school special called *The Boy Who Cried Wolf*. Living with Mariah, and observing the wolf's behavior over the years, Bash was able to learn the wolf's language of communication through body movements and facial expressions. Since dogs are descended from wolves, that experience became an invaluable tool for Bash as he learned how to communicate with canines. Mariah went on to become the symbol of

the 1984 Winter Olympics in Yugoslavia, and was later featured in a Revlon cosmetics advertising campaign for Gypsy Gold perfume.

Bash adopted a mixed-breed dog from a shelter and trained the dog to follow his commands. The dog, Muffin, was cast as a main character on the popular soap opera *The Edge of Night.*

Bash continued to train people's pets, but his experience in the entertainment industry opened some unique doors. He became known as a trainer who was successful in training animals in a gentle and natural way. His reputation spread among friends and acquaintances, and before long he had developed a clientele that included a lot of well-known individuals. He has trained the animals of countless celebrities, including Matthew Broderick and Sarah Jessica Parker, Brooke Shields, Kathleen Turner, Jennifer Lopez, Mariah Carey, Joan Rivers, Kim Bassinger, Alec Baldwin, Ralph Lauren, Calvin Klein, Henry Kissinger, S. I. Newhouse, Ron Howard, and Martin Scorsese.

Bash began training Matthew Broderick and Sarah Jessica Parker's Border Collie, Sally, when

Opposite: *Bashkim ("Bash") Dibra with friends*

she was a new puppy. After Bash had housebroken the puppy and successfully trained her to obey basic commands, Broderick asked him to teach her some tricks. He wanted her to do fun things, like catch Frisbees. Sally learned to do this so well that she demonstrates her talent on Bash's dog-training DVD *Teach Your Dog to Behave.* Sally also used this talent to entertain Broderick's co-stars on set during the filming of his movies.

Sarah Jessica Parker was also "trained" by Bash.... She used techniques taught to her during Sally's training while filming scenes with dogs for her television series *Sex and the City.* Parker also referred to this training while rehearsing for the lead role in a play called *Sylvia,* about a dog named Sylvia. Parker observed her own dog Sally's expressions and used this information to create the dog character, and to craft her onstage performance.

Sally is not the only dog that Bash has trained to entertain famous entertainers. Mariah Carey has a Jack Russell Terrier named Jack. Bash taught Jack obedience and noticed that Jack liked to jump high and catch things. Carey was booked to make an appearance on the *Late Show with David Letterman.* She knew of Letterman's fondness for "stupid pet tricks" and

TRY THIS AT HOME

Many people have called upon Bash to work with their unruly dogs in advance of New York City co-op board interviews, because board members may deny applicants permission to purchase their dream home if their dog is noisy or threatening. Bash has perfected a method to prepare dogs for that all-important make-or-break meeting. He uses the "Three P's" method to tame even the wildest dog:

1. **Patience:** Your dog *can* be trained; however, it is going to take time, and there will be mistakes and setbacks along the way, so remain patient.

2. **Persistence:** Programming your dog to respond to your commands will require reinforcing the same commands, over and over. Use a strong tone of voice, so the dog knows that you are in control of the situation. Keep repeating the same command, and correcting his behavior, until the dog gets it right.

3. **Praise:** Express pleasure and enthusiasm when your dog does what you are asking him to do. "Good Boy," partnered with a pat on the head or a treat, will reinforce that you are pleased with his performance.

Bash has referred to potential pet students as "diamonds in the rough," but with love and training they can "shine like a star."

decided to prepare Jack to demonstrate his abilities on the show. Using Jack's natural talents, Bash taught him to keep a balloon in the air, bouncing it off his nose, without having it hit the ground. He performed this trick for Letterman, who was suitably impressed.

Bash has appeared on many television shows, including *The Today Show, Good Morning America, The Early Show, The Tonight Show,* and on CNN, to promote responsible pet ownership. He also continues to work with dogs belonging to ordinary people, and if you reside in the New York area, or wish to pay for him to travel, he can train your dog, too.

If you live in New York and are unable to pay for Bash's training, or if you live elsewhere in the world and cannot pay for Bash to come to your home, you can still have him help you train your dog. He is the author of six bestselling books, including *Teach Your Dog to Behave, Dogspeak, Catspeak, Your Dream Dog: A Guide to Choosing the Right Breed for You, Dog Training by Bash,* and *StarPet: How to Make Your Pet a Star.* He has also produced a video and DVD, *Teach Your Dog to Behave,* which demonstrates the methods described in his book of the same name. You can buy the books and the DVD at most bookstores or order the titles direct from his Web site, www.bashdibra.com.

Hollywood Hounds

Dog owners on the West Coast of the United States do not have to settle for a "Brand X" pet trainer to tame their unruly animals. Tamar Geller, founder of The Loved Dog Center, a doggie daycare facility in West Los Angeles, has offered in-home training for the past nineteen years to an exclusive circle of pet owners and their dogs. Clients include Oprah Winfrey, who has hosted Tamar on her show; Ben Affleck; Olivia Newton-John; Eric Idle; Nicolette Sheridan; and Goldie Hawn. You can hire her directly, or you can apply her techniques, which she shares in her book, *The Loved Dog.*

She was born in Israel, and after what she describes as a horrific childhood, left home at age eighteen for compulsory service in the Israeli Defense Forces. While training to become an intelligence officer, she grew interested in canine behavior and observed the techniques used to train dogs to serve the military.

After leaving the Israeli armed forces, she spent a year traveling in Southeast Asia and then arrived in Los Angeles for what was to be a short visit. She contacted local dog behaviorists to observe their training techniques and worked briefly with a dog that was stealing his owner's socks. Tamar was able to retrain the dog to substitute sock hiding with playing fetch. The owner was delighted and recommended Tamar to all his friends. The owner was Kenny G, and Tamar's popularity within the Hollywood entertainment community was immediately assured.

Her technique advocates a gentle approach with pets. She says, "You don't have to be a dictator. There are two kinds of leaders, the Saddam Hussein type or the Gandhi type. Both types, people listen to. What kind of dog parent do you want to be?" Hollywood has clearly made its decision, and her popularity continues to grow.

While the affluent and notable may choose to work with high-profile celebrity dog trainers, like the ones mentioned here, most people do quite well with lesser-known behavioral specialists. You can locate a local dog trainer by consulting with your veterinarian or with friends and neighbors who may be able to recommend talented individuals closer to your home. Many communities have obedience classes taught by qualified dog trainers. Precious is a proud graduate of the training program at Wags and Wiggles in Orange County, California (www.wagsandwiggles.com), and displays her diploma with pride.

You can also seek advice from the myriad of books written by dog trainers and animal behaviorists and from the wealth of tapes and DVDs that outline their own special techniques for communicating with dogs. Whatever you ultimately choose to do, be assured that you will be repaid every day by your dog's exemplary behavior.

Fly Me to the Moon

Posh pups go everywhere with their owners, from trips to the local park to shopping at their favorite stores, from a day in the office to a night out on the town. Today, however, more beloved dogs are traveling along with their owners on vacation than ever before. Most pets of the past had to make do with a stay in the dreaded kennel. Even Precious sometimes gets left behind, since Cindy sends her to doggie daycare while she is traveling for business. (But Cindy can watch her from anywhere on her computer by means of the facility's doggie cam, so the two are never far apart....) Yet today more and more well-behaved dogs are accompanying their people everywhere they travel. According to a Harris Poll conducted in 2005 for pet-product manufacturer Hartz Mountain Company, 50 percent of Americans planned

to take their pets along on a family vacation. To accommodate these jet-set pets, airlines, hotels, motels, and even attractions—from theme parks to national parks—are providing pups with entrées and lodging.

The first thing to consider when deciding whether or not to bring along your dog is how healthy, well-behaved, quiet, tame, and adaptable to new experiences your pet might be. If your dog is old, infirm, noisy, aggressive, or connected to his home routine, it may not be a good idea to take him out of his familiar comfort zone. If, on the other hand, your dog does well with short, local outings, he may just be a candidate for a trip away from home.

You should acclimate your pet by taking him out for short local trips in the car and for walks in unfamiliar places to gauge his adaptability to change. If your dog does well with these small outings, it may be time to graduate on to something more challenging, like a car trip out of town for the weekend. Eventually, you can move up to a full-fledged vacation away with your pet. Good gear for a car trip includes a seatbelt or harness system. Several choices you might consider are the PetBuckle and Kwik-Connect kennel system from

www.petbuckle.com; the Roadie seat harness from www.ruffrider.com; the Auto Zip Line Harness, Tru-Fit Smart Harness, Wander Bed, Wander Hammock, or Backseat Barrier from www.kurgo.com; the Companion Utility Vehicle and Smart Ramp from www.mrherzher.com; and seat covers and cargo liners from www.solvitproducts.com.

Good to Go

Prepare for the trip with a visit to the vet, so you can be sure that all inoculations are up to date. Be sure to ask for a written and dated certificate of health and dog tags that show all inoculations, since some hotels may ask for them. Tell the vet about your destination, because the locale may require special medications, like shots for Lyme disease, if there are a lot of mosquitoes. It is also a good idea to purchase a tag with your dog's name, as well as your name and contacts, to hang on his collar, in case he gets lost on your trip. Another option is a microchip that can be inserted under his skin and can be scanned to read his personal and medical information. Most vets can do this high-tech

procedure during the visit. Some vets will pre-scribe a mild sedative if your dog is very excitable in order to relax him during the trip.

Send Your Pooch Packing

Pack for your dog when you pack for yourself. Your pup's suitcase should contain, among other things, his bed, mat, bowls for food and water, a supply of food for the trip (especially if there will be no opportunity to purchase his usual vittles at your destination), some bottled water from home (for refreshments en route), his favorite toys and chews, his collar and leash, his license tag, and a sweater or coat (and even boots if your destina-tion requires them). Remember to bring the health certificate, the identity tags, and any medication that your pet may need. A pooper scooper or plastic bags are necessary, as are all grooming supplies and a first-aid kit.

Finally, it is a good idea to take along a good clear photo of your dog and a written description of him, including any markings or distinctive details, in the unlikely but possible event that your dog becomes lost on the trip. You might put all of this information into a "pet passport," called "Pet Credentials," a thirty-six-page booklet for all of your pet's health and med-ical information. This compact booklet is produced under the license of The Humane Society of the United States. Call 877-269-6911 to order one for your dog.

Be sure to take along an airline-approved closed pet crate, or a travel bag that gives your pup enough room to stand up and turn around. This will be necessary for the time your dog will

Doggie carry-on

CHEW ON THIS

Call My Agent

Pet travel agents who specialize in booking trips for people with their pets include www.voyages withdogs.com, www.tripswithpets.com, www.puppy travel.com, www.pettravel.com, www.flypets.com, www.petflight.com, www.petmove.com, and, in the United Kingdom, www.dogservices.co.uk. These Web sites operate much like Orbitz, Hotels.com, and Priceline, and are helpful resources when planning a trip with your favorite dog.

If Fido must fly, the first thing to do is to check with the airline to learn its policy on flying with a pet. Here are some handy Web sites.

❀ The American Kennel Club offers a useful chart that compares all the airlines' rules and fees at http://tinyurl.com/34r4q8.

❀ The U.S. federal government provides helpful tips for traveling with your pet at www.aphis.usda.gov/ac/pettravel.html.

❀ The Air Transport Association of America can be reached at http://tinyurl.com/2jq62h.

❀ The Humane Society of the United States can be reached at http://tinyurl.com/2z4unr.

A good book to read on pet travel is *Traveling with Your Pet: The AAA Pet Book*. This book can be purchased at any AAA (American Automobile Association) location, at most bookstores, or online. It lists more than 13,000 pet-friendly lodgings or campgrounds in the United States and Canada.

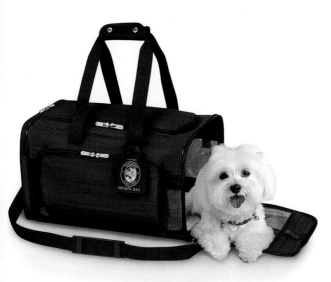

Have bag, will travel

be rolled through huge airports like the finest luggage. Precious the Poodle has about forty (probably more) dog carriers, in colors to match every outfit.

P.A.W. (Pups Are Welcome)

Research your destination before you go, to locate pet-friendly accommodations. Many hotels will welcome your pet if told in advance of his arrival. They will be less welcoming if you spring his presence upon them, or, worse yet, try to sneak him in.

spend alone in the room, without you, as well as onboard the plane. Posh pups swear by the travel bags manufactured by Sherpa's Pet Trading (www.sherpapet.com), which was the first company to offer airline-approved carriers. The company makes them in sizes to fit any dog (even yours), and they are available in a large range of designs and beautiful materials that can match virtually any luggage or outfit you may choose for travel. Some models are designed like a backpack, while others resemble a designer handbag or tote. The most elaborate designs feature discreet wheels, so your dog can

Some luxury hotels, like the Ritz-Carlton, offer special amenities for dogs, such as mono-grammed comfortable beds and blankets, towels, treats and chew toys, special menu items for room service, and spa treatments, including doggie massage for tired muscles. A dog concierge can also locate posh clothing and lifestyle items to purchase for use at home and can book appointments for grooming, spa treatments, or fittings for custom garments and beds.

The W Hotel in Los Angeles is highly recom-mended by Precious (and Cindy). The two often travel to L.A. for the weekend, and they arrive in

time for the popular singles-event P.A.W. Dog Happy Hour (or should it be called Yappy Hour?). P.A.W. refers to "Pups Are Welcome," where pups can accompany their single parents for drinks and hors d'oeuvres, and yes, there are treats and libations for both species! The hotel also offers poolside or in-room doggie massage, pet personal trainers, and even a special room-service menu (Precious recommends the chicken...).

Lots of hotel chains accept pets, including Accor North America, which includes the well-known Motel 6 and Red Roof Inn; Marriott's JW Marriott Hotels, SpringHill Suites, TownePlace Suites, Renaissance Hotels & Resorts, Fairfield Inn, and Residence Inns; Woodfin Suites; Choice Hotels International, which includes Comfort Inn, Comfort Suites, Quality Suites, Clarion Suites, Cambria Suites, MainStay Suites, Econo Lodge, Roadway Inn, Suburban Extended Stay Hotels, and Sleep Inn; La Quinta Inn & Suites; the InterContinental Hotels Group, which includes Staybridge Suites, Candlewood Suites, Holiday Inn Hotels, Holiday Inn Express Hotels, InterContinental Hotels and Resorts, Crowne Plaza Hotels and Resorts, and Hotel Indigo Properties; and DoubleTree Hotels and Resorts.

Many luxury hotels and resorts also welcome pets; examples are the Ritz-Carlton Hotels (check with the location you plan to visit); the Broadmoor in Colorado Springs, Colorado; the Chesterfield, the OC Beach Resort, and the Heart of Palm Beach Hotel, all in Palm Beach, Florida; the Cypress Inn in Carmel-by-the-Sea in California; the Loews Coronado Bay Resort in San Diego, California; the Redwoods Inn in Yosemite National Park, California (the only dog-friendly accommodation inside the park); the Hotel Burnham and the Hotel Monaco in Chicago, Illinois; the Loews Philadelphia Hotel and the Rittenhouse Hotel in Philadelphia, Pennsylvania; the Standard Downtown, the Luxe Hotel Sunset Boulevard, the Loews Santa Monica Beach Hotel, the Raffles L'Ermitage Beverly Hills, and the Beverly Hills Plaza Hotel, all in Los Angeles, California; the Ritz-Carlton, the Hotel InterContinental, the W New York Union Square, the Radisson Lexington Hotel, the Sheraton New York Hotel and Tower, the Novotel New York, and the Maritime Hotel, all in New York City; and the Hotel Vitale, the Marina Motel, the Hotel Triton, and the W San Francisco, all in San Francisco, California. And that's just to name a few....

So, bon voyage, and don't forget to write.

Party Animals!

We're always up for a good party! Pampered pups are valued family members, and their owners want to commemorate the milestones in their lives with parties and events that often exceed in magnitude comparable parties for human guests of honor. According to a survey conducted by the APPMA, 100 percent of dog owners purchase gifts for their dogs. Thirty million dog owners buy holiday gifts for their pets, and 9.8 million dog owners give birthday gifts to their dogs. Surprisingly, 65 percent said that they sing or dance for their pet!

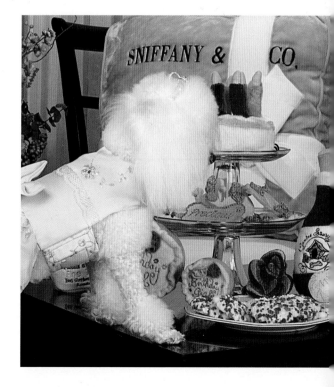

Yappy Birthday to You

Birthday parties are perhaps the most prevalent event on the canine social calendar, because every dog has a birthday once a year. Whereas a birthday might have been celebrated in the past with extra treats or a favorite meal, today pet owners are pulling out all the stops to orchestrate birthday extravaganzas. Cindy celebrates each of Precious's birthdays with a party. She buys a cake from the Three Dog Bakery, because

it is more photogenic than her homemade efforts, and photo opportunities are a primary component of the day's event. She selects music from the dog-friendly CD *Songs to Make Dogs Happy* from the Laurel Canyon Animal Company (www.petcds.com). Created by intuitive animal communicator Dr. Kim Ogden, the CD is the first qualitatively and quantitatively researched musical CD for dogs, based upon the responses of 200 canine participants.

The most elaborate parties may be organized by professional party planners and might be sophisticated, catered affairs, featuring elegant décor, themes, and even swag bags of take-home treats and gifts for each of the guests. (Swag bags are goodie bags like the ones the stars receive at the Academy and Emmy Awards each year.) Many of these events are held at upscale pet stores, or at doggie-daycare facilities, so that all of the canine attendees can roam freely and interact with the other four-legged guests. A birthday cake is usually ordered from a dog bakery, because these businesses understand dog nutrition and know what ingredients may be harmful to pets.

If you think that dog bakeries are a marginal notion, think again. At last count, there were more than 800 dog bakeries located in the

United States, so it is likely that there is one close to you. Google alone shows fifty pages of dog-bakery entries in America and abroad.

The concept of the dog bakery began in 1989 in Kansas City, Missouri. Dan Dye and Mark Beckloff's dog, Gracie, was an albino Great Dane. She was partially blind and deaf, and had stopped eating her food. In an effort to save her life, they began to make food and treats that she would find palatable and eat. Through trial and error, they combined healthful everyday ingredients like peanut butter, wheat flour, honey, fruits, and vegetables to create delicious oven-baked food and treats. Gracie responded to her new food, and shared it with the household's other two dogs, Sarah and Dottie. Soon all of their four-legged friends were eating these home-baked goodies, and a new business concept was born. Originally named the KC K9 Bakery, Three Dog Bakery has thirty-five branches in four countries, and it continues to expand. It has also inspired innumerable other similar businesses in the United States and around the world. Mark and Dan have written four books about the Three Dog Bakery that include stories about their dogs and recipes created for their pets: *Short Tails and Treats from Three Dog Bakery*, *Amazing Gracie*,

CHEW ON THIS
Now You're Cooking

An online search of bookseller sites found close to 300 cookbooks that feature recipes for dogs. Any of these may contain fresh food ideas to delight your dog and his pals at a birthday party or other festive occasion. You can also obtain recipes for dog food and treats online. One dog-related site that maintains a long list of recipes to download and use for your own noncommercial purposes is www.thepoop.com. Three popular culinary Web sites also feature recipes for dog food and treats: www.epicurious.com, which compiles recipes from past issues of *Gourmet* and *Bon Appétit* magazines; www.allrecipes.com, featuring sixty-five recipes for dogs; and www.recipezaar, which has fifty-five dog recipes.

The Three Dog Bakery Cookbook, and *Cooking the Three Dog Bakery Way*. The recipes can be used to prepare festive treats for any dog party. Gregg Gillespie's *Tasty Treats for Demanding Dogs* book comes in a kit with novelty cookie cutters.

Woof Comes the Bride

Birthdays are not the only milestones being commemorated with a party. Indeed, pet owners are happy to celebrate just about any special occasion with their pets. Weddings are typically shared by the whole family, and often pets are included in the ceremony. Many people choose to include their dogs not only in the wedding ceremony and the reception, but also, and especially, in the pictures. Some lucky dogs are attired in tuxedos to match the groom or in bridal gowns to match the bride, or are simply dressed as bridesmaids, groomsmen, flower girls, or ring bearers.

Celebrities often expand upon this concept. Their larger-than-life weddings are typically designed by professionals. Mindy Weiss, who was named by the *New York Times* as one of the nation's top-five wedding planners, revealed in

Emma Rose Design

an interview in *Animal Fair* magazine that performing artists Gwen Stefani and Gavin Rossdale included their Hungarian Sheepdog, Winston, in their wedding ceremony. Another celebrity who included his dog in the festivities was Adam Sandler, whose Bulldog, Meatball, served as ring bearer during his wedding to Jacqueline Titone. Meatball waddled down the aisle dressed in a doggie tuxedo and a white yarmulke. Later, he attended the reception as a "bone-a-fide" guest!

Some dog parents dispense with the human wedding completely and simply host a wedding for their dog to another beloved canine of the opposite sex. A new company in Canada, called "Doggie I Do's" (www.doggieidos.com), specializes in planning elaborate dog weddings. Many dog clothing manufacturers offer wedding dress and tuxedo designs for dogs; there are fifty pages of listings for each on Google. (That's what I call "Black Tie and Tails"!) One online resource is My Uptown Pooch. Precious bought her wedding gown here (just for fun; Precious is unattached), and the Web site shows five different designs, which range in price from $120 to $2,500 each. And don't forget the veil, which costs an additional $82.... My Uptown Pooch also carries tuxedos for the groom. Although some of these

Emma Rose Design

outfits can be used as costumes for Halloween, a large number of customers buy them for their pet to wear to their own wedding.

Perhaps the most elaborate wedding gown ever designed for dogs was shown at the Pet Fashion Week show in New York City. There were many beautiful and extravagant items exhibited throughout the show, but few were as exquisite as the $5,500 handmade wedding gown for dogs by Emma Rose Design. The dog dress was bought by a Pennsylvania-based, online upscale pet clothing and bridal boutique shop, The Gilded Paw. The president of the company, Kristine Moyer, imme-

diately fell in love with the detail and outstanding quality of the handmade pieces when she met the owner of Emma Rose Design, Carol Blanchette. Soon after that, Kristine and Carol became not only business associates, but also friends. When asked about buying the lavish dog wedding dress that was showcased in the fashion show, Kristine had only one response: "We wanted to buy this designer dog dress for those unable to attend the event. We believe a dress like this should be able to be seen by the world so people understand that pet fashion is not just a passing trend."

Emma Rose Design is generally of a higher quality than other pet wedding-gown manufacturers, not only in its structure, but also in the

Above and left: Emma Rose Design

fabric and embellishments that go into its hand-made pieces. The dog dress worn in the fashion show was no exception, with its bodice consisting of more than a thousand hand-beaded Swarovski beads and clear sequins. The dress was all hand-done by Carol and took her a couple of months to finish. The fabric used on the bodice is a Peau de Soie, while the fabric for the luxurious, 10-foot, five-layered train is tulle and has embellishments of rose appliqués with pearls and sequins. When asked about her inspiration for the dress, Carol Blanchette responded that she was "sitting by [her] flower garden [when she] watched the roses and thought of

"Mass Wedding" participants get "cold feet"!

romance and simpler days when everything seemed beautiful." To add a finishing touch to this already exquisite dog dress, the veil is a "bridal illusion" with white satin cording and Swarovski beading and sequins.

The Gilded Paw is a designer pet boutique offering classy and luxury items, such as furniture and apparel. One of the largest online retailers of Emma Rose Design, The Gilded Paw carries a few exclusive pieces, now including the dog wedding dress showcased in the New York Pet Fashion show. To learn more about these fabulous pieces, visit www.thegilded paw.com or www.emmarosedesign.com.

Finally, the Reverend Sun Myung Moon has nothing on dogs when it comes to planning mass weddings. The Aspen Grove Lifestyle Center (www.shopaspengrove.com), an upscale shopping center in Littleton, Colorado, near Denver, staged a mass wedding for dogs in May of 2007. The shopping center bills itself as dog-friendly, and twenty-nine of its fifty-five stores welcome dogs that shop with their owners. The wedding drew 178 dog couples (356 dogs), which has unofficially broken the *Guinness Book of World Records'* recording of twenty-seven dog couples, which took place in the Netherlands. The shopping center planned to submit documentation of the event for official recognition. The event, which raised more than $3,000 for animal rescue, also included Doggie Speed Dating prior to the ceremony, for those dogs that needed a partner to participate in the

nuptials. The reception that followed featured a wedding cake from The Pink Poodle Gourmet (303-800-2885 or 720-528-7886).

Let's Party!

Many special occasions warrant a dog party, such as New Year's Eve, Memorial Day, Fourth of July, Labor Day, "Howl-o-ween," Thanksgiving,

Cupid

Christmas, Hanukkah, and even a "Bark" Mitzvah, when a boy dog becomes a "man" at age thirteen. Traditional ceremonial dress—including a yarmulke and *tallit* ("prayer shawl")—are available from many pet clothing and costume manufacturers. You can find simple how-to instructions on how to organize this Jewish celebration on the "how to" Web site www.eHow.com. There's even a children's book about this event, *Alfie's Bark Mitzvah,* written by Shari Cohen and illustrated by Nadia Komorova. As a special bonus, the book comes with a CD featuring a collection of children's songs created especially for the book by the internationally acclaimed cantor Marcelo Gindlin.

These parties are often held at home and might include a special meal and homemade treats, or they can be more elaborate, catered affairs. *Modern Dog* magazine even has a monthly feature called "The Party" that gives tips on how to plan a party for that month's special occasion.

Features have included parties for New Year's Eve, Christmas, and the Fourth of July. From the theme to invitations, beverages, food, games, and even music, the entire plan is orchestrated for your execution at home.

One new way to commemorate milestones in your dog's life is by commissioning a filmed documentary of your pet that immortalizes your dog and his unique personality for posterity. Dogumentaries (dogs@videovampires.com) promises to "unleash your dog's star power" and "catch your canine's unique character in a short film." The company can edit together existing still photography and videotaped media, or can shoot new "pooch footage" (often filmed at dog level) on location in New York City. The resulting film may consist of interviews with key people and animals in your pet's life, and the final cut will include titles, music, and animation, as well as cover art. You can even order extra copies of the biography on compact disks to tuck into the swag bags.

Two new books show you everything you need to know about planning a party for your dog: *Dog Parties: Entertaining Your Party Animals* by Kimberly Schlegel Whitman and *Dog Parties: How to Party with Your Pup* by Arden Moore.

These books are dedicated to showing you how to plan a blow-out bash for your furry friend. Ideas include themes, locations, decorations, music, games, invitations, favors, and menus for both people and pets. So, when the mood strikes, party hearty!

I'm a Bumble Bee!

TRY THIS AT HOME

Here are ten steps to planning a terrific party for your pup:

1. **Choose an occasion.** Reasons to celebrate include birthdays, weddings, "Bark Mitzvahs," Sweet Sixteen, Valentine's Day, Fourth of July, Halloween, and Christmas.

2. **Choose a theme.** Options include your favorite color, flower, food, place, hobby, TV show, movie, book, or even word....

3. **Choose a location.** Consider your home, a nearby park, a pet store, or a bakery. Just be sure that whatever site you choose is dog-friendly.

4. **Choose a cute invitation.** You can purchase invitations ready-made, or design one of your own using your computer and photos of your pet.

5. **Choose decorations that support the theme.** Examples include red hearts for Valentine's Day and pumpkins for Halloween.

6. **Choose food for people and pets.** Use cookbooks to inspire your selection, or choose your favorite concoctions—the ones you can prepare without poisoning your guests!

7. **Choose drinks for all guests.** A good idea for your human guests is a signature drink that supports the theme and has a clever name, like a *Muttini*. Make sure to include water "drinks" for the dogs.

8. **Choose music to set the mood.** Let your home collection be your guide, or download some fun tunes to support your theme.

9. **Choose fun games and activities.** Group or team efforts can break the ice, and can help introduce strangers to each other; a shared activity can spark conversation. These activities are a great way to include the animals in the party festivities.

10. **Choose Party Favors and Swag Bags.** Cute toys or treats for the dogs are a great choice, and can be as inexpensive and simple as a handful of biscuits tucked into a pooper-scooper bag.

Join Clubs, Make Friends...

C ute dogs provide a wonderful way to meet people and increase your circle of friends. My mother often admonished me to "join clubs and make friends." This is the perfect motto for dog owners seeking to expand their social circles. There are so many pet affinity groups, from dating Web sites for pet lovers to breed-specific dog clubs, that there is unlimited opportunity to connect with people who love their dog as much as you love yours. Focusing on your beloved pet can be the catalyst to meeting a new group of like-minded people.

Puppy Love

A recent Valentine's Day survey conducted by the AKC found that dog owners are actually looking for canine qualities in their *human* partners! Ninety percent of women surveyed found at least one quality in their dog that they would like to see in their significant other. Those qualities included "perennial good mood" (25 percent), "always willing to spend time with you" (21 percent), "always cuddling up on the couch" (20 percent), "motivates you to exercise" (12 percent), and "eagerness to eat your cooking" (11 percent). In fact, 34 percent of the women surveyed agreed with the statement, "If my dog was a man, he'd be my boyfriend!"

Men responded to the survey quite differently than women. Thirty-four percent of them said the top canine quality they hoped to find in women was "always being in a good mood." Other qualities sought by men included "just as happy to hang at home as go out on the town" (16 percent), "always greeting me enthusiastically when I get home" (15 percent), "doesn't get mad when I want to watch sports" (15 percent), and "being up for anything I want to do" (11 percent). Only 23 percent of the men surveyed agreed with the statement, "If my dog was a woman, she'd be my girlfriend." An interesting difference between the sexes to ponder....

The poll also found that 58 percent of men have discovered that a puppy is a foolproof magnet for attracting women, and 46 percent of women said that they would stop to talk to anyone with a cute puppy. This is especially true in an urban setting, where people tend to walk their dogs. City dwellers are known to their neighbors as the "mother" of certain dogs (like "Fluffy's mother"), because people recognize

the dogs in their neighborhood, and generally ask the pet's name. This simple method can be the first step in connecting with people in your neighborhood, and it can be a way to get acclimated in a new place.

Twenty-five percent of women and 16 percent of men said that their dog sleeps in bed with them. Forty-four percent of these people admitted that their dog gets more room in bed than they do! Fifteen percent found that their partner is envious of their relationship with their dog. These were some of the reasons: "because I dedicate so much time to my pet" (43 percent), "the dog likes me better" (33 percent), "I prefer to cuddle with my dog than with my mate at night" (12 percent), and "things have been tense since I did more for the dog's birthday than I did for my partner's" (3 percent). Eighteen percent have included (or would include) their pet in their wedding ceremony, and 60 percent said that if they split up with their partner, they'd definitely get the dog. Lastly, 14 percent admitted that they might continue to date someone they didn't like all that much just to spend time with their dog, putting a whole new spin on the statement, "Love me, love my dog!"

Dog Lovers Only

Single people often have a dog to keep them company. Cindy and Precious demonstrate this demographic. Cindy's license-plate frame says, "Love Me, Love My Poodle," to give men fair warning not to even bother approaching her if they have an issue with her infatuation with her small dog.

The people/pet relationship can have additional benefits. According to that AKC survey, 66 percent of dog owners said that they wouldn't even consider dating someone who didn't like their pet. This sentiment is the premise behind a number of Web sites for single dog owners. These Web sites will connect pet owners to other compatible people who love pets. Dog people tend to be kind and caring, to take an animal into their home, and share their life with their pet. These same qualities make them the kind of people to respond warmly to other pet owners. A number of singles groups have chosen to capitalize upon these traits.

Dogs in Cyberspace

Singles are not the only ones who wish to connect to a community of dog lovers. One popular Web site is www.dogster.com, where you can post your pet's profile with your own, create a blog, and upload pictures of your dog (and of yourself) to share with other dog lovers. Ted Rheingold launched the site in 2004, and today the site boasts more than 252,000 members. It was named the "*Times Magazine* Site of the Year" and the "Webby Awards Community of the Year" in 2005. Currently, there are 205,000 dog pages, more than 400,000 forum postings, in excess of 3,000 dog groups, 36,208 dog diaries kept, and 974,593 dog photos.

CHEW ON THIS
Heavy Petting

There are a number of computer dating sites for pet lovers. Here are some we've found:

www.datemypet.com

www.lovemelovemypets.com

www.animalattraction.com

www.pamperedpuppy.com

www.petspassions.com

www.animalpeople.com

www.doglover.com

www.dogup.com

www.mustlovepets.com

www.petsfriends.com

www.petloversconnection.com

www.petpeoplemeet.com

www.petpeoplefishing.com

www.singlepetlover.com

www.petdate.co.uk

www.petloversonline.co.uk

Dog groups are a great way to find dog owners who share your interests and values. Some people have made lifelong friends on the site.

Other popular online pet communities include www.thepoop.com, where you can commemorate your pet's birthday, share recipes for homemade pet foods and treats, and even memorialize your pet after it has gone. Another good resource for both dog owners and owners-to-be is ww.dogs.about.com. This site will connect you with a wide range of services for dog owners, and can help those contemplating adding a dog to their family by giving them good information so that they can select the best dog for themselves. Another portal to a range of interesting and useful dog information is www.dogchannel.com. The site is broken into sections: Club Dog, where you can create a Web page for your dog and post a blog; Show Dog News, which features information about sanctioned dog shows; Online Community, where you can participate in message boards and online forums; Breed Resources, where you can find information about breeds, breeders, and adoption opportunities; and Stay

Informed, which includes news updates and advice on health, nutrition, and training.

Consider connecting with the American Kennel Club (www.akc.org) for a number of ways to find other pet lovers. If your dog is purebred, he may already have AKC registration. You can trace his lineage at this site. You can also connect with breed clubs, breed enthusiasts, and breeders who share an interest in your dog's breed. There are also a lot of interesting things to learn about purebred dogs on this site.

Get on Board with Cause

Community-minded dog owners can connect with a cause, and meet similarly committed dog lovers, by volunteering to help at a number of nonprofit organizations that support pet welfare. The American Society for Prevention of Cruelty to Animals (the ASPCA) is the country's oldest humane society, founded in 1866 by Henry Bergh. It continues to pursue its original mission "to

provide effective means for the prevention of cruelty to animals." The ASPCA is supported by more than one million members and donors across the United States. National programs include Humane Education, Government Affairs and Public Policy, Shelter Outreach, and the ASPCA Animal Poison Control Center, which together support the goal that no animal should live in fear or pain.

The ASPCA National Outreach department provides financial assistance and support to shelters nationwide. In 2005, ASPCA staff provided advice and information to more than 8,000 animal protection organizations and citizens in all fifty states and more than 100 countries; provided on-site visits and expertise to 242 shelters in thirty-two states and Puerto Rico; presented 220 training seminars and workshops to shelter professionals across the United States; and provided $626,327 in grants to 200 animal

protection organizations in forty-four states, the District of Columbia, Puerto Rico, and Canada. This is a worthy organization to support, and your dog will join you in the gratification derived from making another dog's life worth enduring.

The Humane Society of the United States (HSUS) maintains a Web site, www.petsforlife.org, and is the nation's largest animal protection organization, with more than seven million members and constituents. The HSUS is a mainstream voice for animals, with active programs in companion animals, wildlife and habitat protection, animals in research, and farm animals. The HSUS protects all animals through legislation, litigation, investigation, education, advocacy, and fieldwork. A nonprofit organization, The HSUS celebrated its fiftieth anniversary in 2004, is based in Washington, D.C., and has seven regional offices across the country. For more than a half century, The HSUS has stood as the nation's most important advocate for local humane societies. Additionally, The HSUS operates its own network of sanctuaries, providing care and homes to more animals than any other national animal protection organization in the United States. The Web site features lots of articles of interest to dog owners, and is an excellent source of information for both adults and children. It also maintains an online store. Profits from the products that are sold fund The HSUS's programs and activities. On a local level, you can locate clubs, groups, and programs for dog owners through your veterinarian, pet stores, dog park, groomer, boarding kennel, and humane societies. Many community organizations also form clubs for dog owners so that they can meet each other and exchange information. In these many ways, your relationship with your favorite furry friend can lead to connections within the community, and the world.

Paper-Trained

I f you wish to do some reading about dogs, be sure you have a serious amount of free time you can allocate to doing this. An online Web search found 324,685 books that include the word *dog* in the title or subject matter. While many of these may not actually focus on domestic canines, Barnes & Noble (www.barnes andnoble.com) lists 2,578 books that actually pertain to dog ownership, care, and the relationship between dogs and their owners.

Magazines can provide a quick fix of dog-related information, but you'll need to block out a significant chunk of time to completely cover the offerings. Not including those titles with less appeal for pampered pups (*Working Dog, Gun Dog, The Pointing Dog, Bird Dog News...*), our research turned up twenty-six consumer magazines that would interest most dog owners!

Cindy subscribes to several popular dog magazines, because she likes to remain ahead of the fashion curve, so that Precious can always be the first with the best. She is particularly interested in learning about the latest products and services, as well as dog-related legislation. Precious's favorite reading materials are *Doggie Vogue* and *Bark Street Journal*, though there are enough titles and topics to please every reader.

Magazine Roundup

These magazines are especially worth spending your valuable time and money on. You may subscribe to any of these magazines directly from its publisher, or you may purchase them online or at local bookstores.

AKC Family Dog Published by The American Kennel Club, this magazine is for the pet owner who wants his or her family to have a satisfying relationship with their dog. Professional-quality content is presented in an easily readable format.

Animal Fair This is an upscale, glossy magazine that covers the urban dog (and cat, too) with articles about lifestyle, health, grooming, nutrition, travel, fun things to do with your pet, and lots of new or special products. Each issue also features a celebrity profile.

Bark Originally founded in Berkeley, California, as a community newsletter to support off-leash legislation, this award-winning magazine calls itself "The Modern Dog Culture Magazine." For the past ten years, it has covered the evolution of the societal movement of dogs. That said, this is a fun and readable magazine that covers all aspects of the people/dog connection. Features include health, behavior, travel, recreation, art, and literature. To subscribe, contact the publisher at www.thebarkmagazine.com.

Dog & Kennel A magazine for dog lovers, this title covers training, health, feeding, grooming, bonding with your pet, as well as doggie events. It also promotes the companionship of dogs.

Dog Fancy This magazine provides information about all aspects of dog companionship, from diet and grooming to breeds, medical care, and pet-show news. The magazine also provides show schedules, information about new dog products, and more for readers who are pet owners, breeders, and show exhibitors.

Dog News This magazine, directed at dog-show enthusiasts, features show results, top-ten statistics, profiles, photographs, and breeder and handler directories.

Dog Watch This newsletter from The College of Veterinary Medicine at Cornell University presents information about animal health that is of interest to dog owners.

Dog World This is a magazine for serious dog enthusiasts, including professionals, obedience exhibitors, groomers, kennel operators, veterinarians, breeders, and just plain dog owners. Contents include health, training, nutrition, breed standards, grooming, breeding, dog shows, legislation, and breed characteristics.

Dogs Annual This annual Canadian one-issue magazine features basic information about dog ownership. It also serves as a vehicle to advertise dog breeders throughout Canada.

Dogs for Kids This magazine title was created for children and teens who want to learn more about dogs as well as how to live with and care for their own pet. Each issue contains a breed profile, training tips, and lots of fun games, puzzles, and posters. The objective is to use fun methods to learn about how to care for your pet.

Dogs in Canada A popular pet magazine in Canada, this publication contains information of interest to people who own, show, or breed dogs. It also contains an extensive breeder directory to assist potential dog owners in locating a dog.

Dogs in Review A magazine dedicated to dog-show enthusiasts, this publication features as much editorial content as pages of advertising (an apparent rarity in this particular magazine genre).

Dogs Life The top dog magazine in Australia and New Zealand, it contains information about nutrition, training, health care, behavior, and all else of interest to people who own dogs. Every issue features an in-depth profile of a breed, and an article for children.

Dogs Monthly A magazine published in England for dog owners and enthusiasts, this title calls itself "The Quality Dog Magazine." It bridges the worlds of professional dog publication and consumer-oriented pet magazine. The magazine features an extensive listing of dog breeders in the United Kingdom, and many readers subscribe for this feature.

Dogs Today This is a British magazine devoted to dog owners and lovers. Each issue contains 125 pages of articles about grooming, health, advice, behavior, breeding, traveling, and more.

Fido Friendly Billed as "The Travel Magazine for You and Your Dog," each issue features travel destinations that welcome you and your globe-trotting pup.

Hollywood Dog This title is published by the same people as *New York Dog;* it is a West Coast version of that sophisticated, glossy dog magazine. It sometimes shares stories with its sister publication.

Modern Dog A lifestyle magazine for urban dogs and their companions, this upscale publication

features stories about pet care, fashion, travel, health, and new products—everything that is new or special for dogs.

National Dog This is an Australian magazine that features profiles of dogs and owners, dog-show coverage, breeder guides, and all manner of information of interest to dog owners.

New York Dog This *Vanity Fair* for dog lovers features fashion, lifestyle, health, nutrition, "biting humor," great writing, and a lavish look most other magazines would die for.

Our Dogs This has been the leading British canine magazine since 1895, serving the needs of breeders, show exhibitors, and dog owners. It offers especially good coverage of the British dog-show scene and features a directory of breeders.

Poodle Review The oldest Poodle publication in the world (over 50 years), this magazine has a readership in excess of 4,000. The contents include in-depth interviews with breeders, columns by people who own and love Poodles, special features, show results, and a breeder directory available to paid subscribers.

Ringleader—The Dog Annual Published by the same company as *National Dog, Ringleader* is an Australian annual guide to dogs, dog care, shows, and breeders.

Whole Dog Journal This magazine provides readers with comprehensive information about all aspects of natural dog care and training. It promotes a "green" approach to dog rearing.

Your Dog (England) Although named the same as the magazine that follows, these two titles have no connection to each other. Britain's best-selling dog magazine, this title covers anything a dog owner would need to know about dogs. The magazine conducts an annual survey of its readers to determine the best products for dogs, which is a particularly popular feature.

Your Dog (United States) This magazine is produced by the Tufts University's Cummings School of Veterinary Medicine and offers an academic approach to care, training, diet, and health for your dog.

Inside Information

Several trade magazines distributed to members of the pet professions may be of interest to people who own dogs. These magazines are often the first to write about new developments in health, nutrition, and pet care, and new products are often debuted within their pages. So, if you are the kind of person who wants to be the first to know about anything dog-related, some of these magazines might be for you.

Pet Age This magazine describes itself as providing "Practical Ideas for the Busy Retailer of Today...and Tomorrow." Information pertinent to all species of companion animals is covered here. You may subscribe by contacting the publisher, Backer Publications, at www.petage.com.

Pet Business This magazine is devoted to covering the entire pet-product industry, so expect to see information about products for all companion animals in addition to dogs. For subscription information, contact the publisher, Macfadden Pet Business, at www.petbusiness.com.

The Pet Elite This new magazine covers the latest and most sophisticated dog products, and serves as a showcase for all of the most fashion-forward pet-product manufacturers. It is designed to look just like a fashion magazine produced for women. To order the magazine, check the Web site www.thepetelite.com.

Pet Product News International This is an oversized-format magazine, which bills itself as "The Leader in Pet Supplies Marketing for 61 Years." Published by BowTie Inc., it covers products for all species of companion animals. To subscribe, contact the publisher through www.petproductnews.com.

Pet Style News Billing itself "The Leader for Boutique Fashion, Products & Trends," this magazine is published by Bowtie News, which also publishes other pet trade magazine titles, as well as pet books and magazines for consumers. This oversized magazine format features lots of news about the industry, as well as many new and fashionable products for dogs. The magazine can be ordered from the publisher at www.petstylenews.com.

❀ ❀ ❀

By reading these publications, you will gain an insight into the pet-product industry, and be positioned to treat your pampered pup to the latest and greatest developments in the marketplace. A posh pup expects no less....

Do(g) It Yourself: Arfs and Crafts

Your crafty dog is a regular Mutt-tha Stewart! With the help of a few books and kits, your pup can whip up clothes, home decorative items, and gifts, and even produce gallery-quality artwork. You can also get into the act by creating fun gifts and garments for your favorite pup by following the instructions provided in these books and kits.

Dog-Gone Knits

Knitting is hot! So are dogs! It was only a matter of time before some people thought to put them together. There are several good knitting books published that feature dog sweaters. My favorite (and in the interest of complete disclosure, I am the author) is

Stylish Knits for Dogs: 30 Projects to Knit in a Weekend, by Ilene Hochberg. As I mentioned, I used to design dog fashions, and sweaters were my bestselling items. My book combines beautiful and well-designed sweaters for dogs with matching sweaters and accessories for their people.

Other dog knitting books include *Doggie Knits* by Corinne Niessner, *Knitting for Dogs* by Kristi Porter, *Men Who Knit & The Dogs Who Love Them* by Annie Modesitt, *Knits for Pets* (Vogue *Knitting on the Go* series) by Trisha Malcolm, *Doggy Knits: Over 20 Coat Designs for Handsome Hounds and Perfect Pooches* by Anna Tillman, *Top Dog Knits: 12 QuickKnit Fashions for Your Big Best Friend* by Jil Eaton, *Dogs in Knits: 17 Projects for Our Best Friends* by Judith L. Swartz, *The Gift Knitter: Knitting Chunky for Babies with Four Legs and Two* by Tara Jon Manning, and the ever-popular *Knitting With Dog Hair: Better a Sweater from a Dog You Know Than from a Sheep You'll Never Meet* by Kendall Crolius and Anne Black Montgomery. All of these books are probably available from wherever you buy books.

Crafty Canines

Posh pups can get their people to create other great things for them as well. The books *Dog Crafts (Kids Can Do It)* by Linda Hendry, *The Dog Lover's Book of Crafts: 50 Home Decorations That Celebrate Man's Best Friend* by Jennifer Quasha, and *Pet Crafts: 28 Great Toys, Gifts*

TRY THIS AT HOME

Knit your dog a sweater! The simple instructions, given earlier in this book, on pages 31–33, are adapted from my book *Stylish Knits for Dogs*. If your dog is small, you can probably knit a sweater while watching television tonight, and you will be done before the end of the eleven o'clock news!

Tillamook Cheddar

and Accessories for Your Favorite Dog or Cat by Heidi Boyd each feature a selection of simple-to-make projects that produce items that will delight your favorite dog. Projects include fanciful doghouses, collars, lamps, jewelry, mats, chew toys, and other fun accessories that will be a joy to own and use. These books are also generally available wherever books are sold.

Pup Art

Making these simple and easy crafts will give you confidence to send your dog where few dogs have dared to go before—the art studio, and the world's best-known art galleries.

Tillamook Cheddar, Tillie to her friends, is a Jack Russell Terrier from Brooklyn, New York. Widely regarded as the world's preeminent canine artist, she has already had fourteen solo exhibitions in the United States and Europe. Tillie is seven years old. In July 2005, the artist gave birth to six healthy puppies. Her first official biography is called *Portrait of the Dog as a Young Artist,* and is written by F. Bowman Hastie III and published by Sasquatch Books.

How does Tillie work? According to Hastie's book:

In preparation for each of Tillie's works, her assistants assemble a touch-sensitive recording device by affixing a pigment-coated vellum to a sheet of lithograph paper backed by matte board. The artist takes the prepared "canvas" in her mouth and brings it to her workplace. Working on the outside surface, she applies pressure with teeth and claws. The resultant sharp and sweeping intersecting lines complement the artist's delicate paw prints and subtle tongue impressions, which are revealed on the paper beneath when she is finished.

How have the critics responded? With a mix of shock, awe, and apprehension:

- "The most successful living animal painter." —*The Art Newspaper*

- "A masterpiece of conceptualism." —*Time Out New York*

- "When possessed by an artistic vision, Tillie is fearless." —*AKC Gazette*

• "Because of Tillie I have had to rethink two of my most basic assumptions about art and life: first, the notion that animals cannot have an aesthetic sense; second, the core conviction that no sentient being could possibly paint anything worse than what Julian Schnable recently showed at the Gagosian Gallery."
—James Gardner, *New York Post*

• "A sham." —Jerry Saltz, *Village Voice*

You can learn more about Tillamook Cheddar and her work on her official Web site, www.tillamookcheddar.com.

Pop Art Pet

Your dog can prepare for a similar life in art by using Pup-Casso, the world's first paint kit for pets, which can be found at www.art-casso.com. Did you know that your Poodle can doodle, your Dachshund can draw, your Pomeranian can paint? Well, now they can! In only three steps, your pup can create a masterpiece. First, place the paint on the art paper. Next, cover the paint with the paw protector. Finally, and most importantly,

place your dog on the "canvas" and let him paint! Will your pup be the next Tillamook Cheddar, Andy Warhund, Jackson Pawluck, Vincent Van Dogh, Pablo Pawcasso, or Julian Schnauzer? Only time and talent will tell....

Finally, if your dog is not artistically gifted, you can gift it with a pup "pawtrait" from a company called "Pop Art Pet" (www.popartpet.com). You simply send them a good-quality photo of your dog, and they use the image to create an exciting work of pop art featuring your pet. Some look like Andy Warhol silk screens, while other humorous ones feature a comic strip bubble over your dog's head to show what it is thinking. Its Web site provides lots of fun options to immortalize your pet. My Dachshund Kelly's portrait on the dedication page was created by Pop Art Pets.

Left and above: *Pop Art Pet*

Dr. Dog

Posh pups eat well, get plenty of exercise, and have lots of beauty sleep. Sometimes this is not enough for your dog to maintain optimal physical condition. An occasional visit to the veterinarian can keep your pet bright-eyed and bushy-tailed, and really, really healthy!

Visiting the Vet

A national survey of pet owners conducted by the APPMA states that the average dog is taken to the veterinarian twice a year. (Precious recommends that you take along your pink "minky" blanket to stand on while in the vet's office. Why stand on a cold stainless-steel table if you don't have to?) According to the survey, vaccinations (68 percent) and routine exams (63 percent) are

the primary reasons for those visits, with flea and tick care (39 percent), specific illness care (25 percent), advice about food and treats (14 percent), dental care (10 percent), and boarding (7 percent) making up the remainder of visits noted. The average amount spent per year for veterinary care is $219; surgical care is $453; vitamins and supplements are $77.

The anthropomorphism of pets has created demand for medications to treat separation anxiety, depression, and obesity. Forty percent of dogs in America are overweight. (There are many ways to get your pudgy pup in shape. Chapter 6 of this book, "You Are What You Eat," addresses this important health issue in great detail.) Pfizer's canine weight-loss aid, Slentrol, costs $1 to $2 per day. Reconcile, a new drug from Eli Lilly, treats separation anxiety, and contains the same active ingredients as Prozac. "Prozac Nation" has gone to the dogs! Additionally, plastic surgery is becoming an option for many dogs. Rhinoplasty, eye lifts, root canals, braces, and even porcelain caps for chipped teeth are available to help Phydeaux be the best he can be. Yet, only 3 percent of pet owners have pet health insurance for their dogs. Many of these medications and procedures are not deemed medically necessary, so they remain the financial responsibility of the pet owner.

Insuring Your Pet's Health

While many of us can afford $750 a year for pet care—the average noted in the study above—pet insurance may be a worthwhile investment to protect us and our pet in the case of catastrophic illness or injury. Pet insurance can cost from $2,000 to $6,000 over the life of your pet, and you may never have to pay this much for medical care. But, if you are the kind of pet parent who would do anything to save your pet in the case of accident or illness, pet insurance may be preferable to going into debt.

Veterinary medicine has come a long way in recent years, with more tests and treatments available for our pets than ever before. These advances, however, have come with a price. Many are very costly, and unless you have good pet insurance coverage in place, you may find yourself facing the question "How much is your pet's life worth?" This is not a decision you should face while coping with his illness or injury.

The pet insurance industry has been around for more than twenty years, but until recently, few were aware of its existence. The traditional customer base consisted of young, white, single urban women; however, today the demographic extends far beyond the initial group. If you think an insurance plan will benefit you and your pet, in the United States you can contact the following well-known pet insurers to compare prices and coverage:

- *Veterinary Pet Insurance*
 (800) USA-PETS
 www.petinsurance.com
- *Premier Pet Insurance*
 (877) 774-2273
 www.ppins.com
- *PetCare Pet Insurance*
 (866) 275-PETS
 www.petcarepals.com
- *Petshealth Care Plan*
 (800) 807-6724
 www.petshealthplan.com
- *TruePaws Family Pet Insurance*
 (877) 832-6195
 www.truepaws.com

The American Veterinary Medical Association (AVMA) is the professional organization for veterinary medical professionals. Its Web site, www.avma.org, is a source of good information about pet health, and the organization produces a number of brochures pertinent to pet health and care. The British Veterinary Association, the Australian Veterinary Association, the Canadian Veterinary Medical Association, and the World Veterinary Association are additional sources of information about pet health options.

Several medical centers are highly recommended if you have a pet facing a complex medical issue that cannot be resolved at your local veterinarian. The following are some of the better-known animal medical centers affiliated with veterinary schools that can treat severe injuries and illness:

- The Animal Medical Center, New York, NY
 (212) 838-8100
- The College of Veterinary Medicine at Cornell University, Ithaca, NY
 (607) 253-3932
- University of Pennsylvania School of Veterinary Medicine, Philadelphia, PA
 (215) 898-4525

- Tufts University School of Veterinary Medicine, Grafton, MA (508) 839-7966
- University of California School of Veterinary Medicine, Davis, CA (530) 752-3602
- University of Florida School of Veterinary Medicine, Gainesville, FL (352) 392-4700
- Colorado State School of Veterinary Medicine, Fort Collins, CO, (970) 491-1242

CHEW ON THIS

When to Take Your Pup to the Vet

- ❀ Immediately after purchase or acquisition
- ❀ Immediately after any injury
- ❀ Immediately after ingesting anything dangerous or poisonous
- ❀ Annually or as recommended by your vet for checkups and inoculations
- ❀ Before any trip
- ❀ If your dog seems listless
- ❀ If your dog appears to be in pain
- ❀ If your dog is bleeding, vomiting, has diarrhea, is urinating excessively, or has an unusual discharge
- ❀ If your dog is scratching excessively, or has been bitten by a parasite or other animal
- ❀ If your dog is drinking excessively
- ❀ If you feel any unusual lumps or bumps under its skin
- ❀ If your dog is limping or moving in an unsteady manner
- ❀ If your dog is losing weight or is disinterested in its food
- ❀ If your dog has gained weight suddenly or unexpectedly

- University of Minnesota School of Veterinary Medicine, Minneapolis, MN (612) 625-1919
- Washington State University College of Veterinary Medicine, Pullman, WA (509) 335-5704

Naturally Healthy Dogs

Five percent of dogs have been given a homeopathic remedy in the past year. The American Holistic Veterinary Medical Association (AHVMA) is an organization for practitioners of alternative and complementary areas of health care in veterinary medicine. Its Web site (www.ahvma.org) provides visitors with simple information like "What is holistic medicine?," "Find a holistic vet," and "Public Information and Events." Its site is a good place to learn about alternative medical therapies for your pet.

Two companies provide homeopathic remedies that you can administer to your dog at home. Newton Homeopathics (www.newtonlabs.net) has been in business for twenty years. Founded by Dr. Luc Chaltin from Belgium, the company has developed a complete line of treatments for pets, including remedies for bowel discomfort, cough and asthma, diarrhea and gas, doggie breath, ear relief, ear irritation, flea and bug bites, nervousness, fatigue, rheumatic pain, and skin relief.

Pedigreen (www.pedigreen.us) offers three kits of homeopathic remedies for pets. The First Years Kit contains preparations for teething, fear or anxiety, travel sickness, post-vaccination pain, and scrapes and bruises. The Active Kit offers remedies for exhaustion, burns, minor trauma or puncture wounds, swelling or irritation from bites and allergic reactions, and cuts and abrasions. The Senior Care Kit provides relief from joint stiffness, inflammation, depression, post surgical healing, and cuts, bruises, and skin irritations.

Smile!

Precious the Poodle loves having her teeth brushed with her peanut butter–flavored toothpaste. Three out of ten dog owners have dental products for their pet, including a toothbrush, toothpaste, mouthwash, tartar and breath

CHEW ON THIS

You've Got Male

Fido feeling a little naked after being neutered? Now, there's a fix for the fix. Neuticals are testicular implants for dogs. Ranging in size and price from $94 per pair to a whopping $919, this implantable body-part replacement will convince Fido, and anyone else who is looking that way, that it never really happened! Learn more at www.neuticals.com. (I'm sure that you're thinking "Now I've seen everything!" Perhaps now you have!)

control, whitening products, and floss. When dental procedures are performed on a dog, the work is typically done at home. You can purchase innovative dental-care products from Petosan (www.petosan.com), which offers a power toothbrush designed for dogs; PetSmile (610-649-8486), which has a self-contained toothpaste with its own built-in brush; DoggieDents (800-297-1998), offering pre-pasted disposable toothbrushes for dogs; PetzLife (www.petzlife.com), makers of an oral care spray and gel; ProDen (www.international-dental.com), offering PlaqueOff, which is sprinkled over food daily to reduce tartar, plaque, and bad breath; and In Clover (www.inclover.com), makers of Dental Savvy Snax, which are chewy dental nibs for dogs. And, if all else fails, EctoThink produces Dog Breath!, tablet-shaped breath-freshening treats (www.ectothink.com).

"Who's Your Daddy?"

Finally, if you think that people are the only ones with paternity issues, think again. Meta Morphix (www.mmigenomics.com) produces a DNA test for dogs. That's right—you can subject your mixed-breed pup to a DNA test that will determine his parentage! The test can identify up to thirty-eight major breeds, so that you can finally know whether the dog next door or the one around the corner is Fido's father, or whether your dog Kaboodle is a Labradoodle, Goldendoodle, or Schnoodle.

The Great Doghouse in the Sky

We all wish that our beloved pup could live forever, but sadly, this is not possible. One day, hopefully a long time from now, we must bid our best friend good-bye. While we all wish and pray that our pet will drift away in his sleep, this is not usually the case. We will recognize when our friend's bad moments outnumber the good ones, and we will know in our heart that the kindest thing to do is to let our friend go.

Fortunately for dogs, there is no need to read a book like *Final Exit* (by Derek Humphry) to put our pet out of its pain. Euthanasia, humanely administered by injection, is available to all our animals at their time of need. This can be done at the veterinarian's office, or at home, as some services will provide a licensed vet to make a house call at this special time.

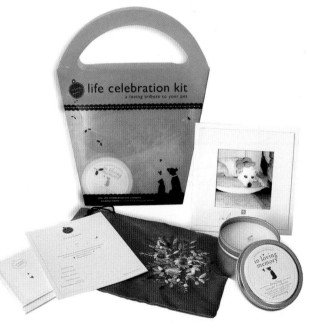

In Memoriam

Unlike for people, there is no prescribed ritual, no funeral, no wake, shiva, or other balm for our emotions. Those left behind are often bereft, and unless you are among people who know and love pets, there is often little sympathy or comfort provided by others on the loss of your beloved pup. People unfamiliar with the pet-people bond will expect you to shrug off your loss and get over it. Move on.

Pet people understand that the sense of loss felt over the passing of a furry friend can be an intense emotion. You will need time to grieve in order to cope with your loss. Today, there are many options for comforting those who have pets and memorializing your own departed pet and even ways to bond once your best friend has gone.

They Live Forever in Your Heart

A study published by the APPMA states that pet owners often take extraordinary measures upon the death of their pet. This may include purchasing an urn for the pet's ashes, a head-stone for its gravesite, a memorial or garden stone, a grief book or kit to memorialize the pet, or a pet keepsake book (which can cost $100 for a small version). Taxidermists are even offering to freeze-dry a pet for perpetual preservation, at a cost of $1,000 or more.

A simpler gesture is to send a sympathy card to those who are grieving the loss of a beloved pet. Paper Russells (www.paperrussells.com) prints a line of beautiful greeting cards for and about pets. The company offers four different designs for dogs. The cards are illustrated with paintings by its artist, Zoe, and the sentiments are perceptive, not cloying. Here are some examples: "Good friends are like stars. You don't always see them but you know they are always there" and "I know how you feel...I just don't know what to say."

Luxepets (www.luxepets.com) is a company known for decorative pet collars, leashes, and charms. When the owner of the company lost her beloved dog, Sophie, she set out to create the In Loving Memory Collection, which includes tasteful memorial urns, keepsake bags for precious mementos like your pet's collar and favorite toy, memorial candles, remembrance cards for the departed dog's closest friends,

Memorial candles

sympathy cards, and a dog lover's sympathy kit, comprised of a keepsake sachet, a pet memorial candle, remembrance cards, a gift enclosure card, and an In Loving Memory picture frame, which can be given to someone who has suffered such a loss.

The savvy mass merchant Target (www.target.com) offers a collection of memorial stones for pets. These can be used to mark a gravesite, or can be placed in the pet's favorite spot in the garden.

You can choose to keep your pet close to your heart by turning his remains into precious stones to be set into memorial jewelry. LifeGem can create beautiful gemstones from the remains of your beloved companion. The company uses a synthetic diamond-making machine to turn the carbon from his remains into a gemstone, which can be placed into the setting of your choice. Learn more at www.lifegem.com.

Your pet can live on in a memorial garden that thrives on the nutrients provided by his remains. A company called Floramorial (www.floramorial.com) will convert your pet's ashes into a nutrient that attaches to plant life. This creates a nutrient-dense soil that will sustain verdant plant life, creating a living memorial to your beloved dog.

Your pet can also live on in memory through a contribution in his name to one of the many worthy animal charities, like the ASPCA, The Humane Society of the United States (HSUS), or your local animal shelter. The choice is up to you, but all of these organizations and many others work tirelessly to improve the lives of pets everywhere.

A Shoulder to Cry On

Sometimes it is necessary to connect with others who understand your pain. There are several Web sites that will help you cope with the loss of your pet, including the Association for Pet

Loss and Bereavement (APLB). This organization is the only one of its kind worldwide, and offers free counseling and emotional support to those dealing with such a loss. They provide a variety of services, and can be found at www.aplb.org. The Pet Loss Support Page (www.pet-loss.net) will also help you cope with the sorrow of losing your pet. The Pet Loss Grief Support Web site (www.petloss.com) is another good choice for compassionate advice. In Memory of Pets (www.in-memory-of-pets.com) offers tributes, poems, and candle-lighting ceremonies, as well as links to services that will be helpful for those who are grieving over the loss of a pet. The Virtual Pet Cemetery (www.virtualpetcemetery.org) is a site that provides people with a way to virtually commemorate their deceased pets. This Web site was created twelve years ago and is the best-known pet cemetery in the world. You can place an epitaph on it that may be read by the millions of people who visit the site each year.

Many veterinary medical schools, humane societies, and community volunteer centers offer pet-loss support hotlines. Some of the best known are listed here.

The Great Beyond

If you wish to remain in touch with your deceased pet, you can make contact through a pet psychic. Joy Turner, who writes a column in *Modern Dog* magazine (www.moderndog magazine.com), and who hosts a radio talk show on the Animal Radio Network (see www.animal radio.com for scheduling), can communicate with your late dog. You can submit questions to either the magazine or radio show, or she can be reached at www.talkwithyouranimals.com if you wish to arrange for a personal session.

Regardless of how you choose to memorialize your dog, you will think of him always, and he will remain in your heart and memories. In this way, your pet will live on and continue to provide love and comfort to you and to others forever. No dog's life mission could be greater than this.

PET-LOSS SUPPORT HOTLINES

UNITED STATES

Arizona

Companion Animal Association of Arizona
Scottsdale
Telephone: (602) 995-5885
Web site: www.griefhealing.com

California

University of California School of
Veterinary Medicine
One Shields Avenue, Davis 95616-8747
Business Telephone: (530) 752-3602
Telephone Hotline: (800) 565-1526

The Grief Recovery Institute
Beverly Hills
Telephone (toll-free): (888) 773-2683 or
(800) 334-7606
Web site: www.grief.net

Colorado

Colorado State University School of
Veterinary Medicine
Fort Collins
Telephone: (970) 491-1242

Florida

University of Florida School of
Veterinary Medicine
Gainesville
Telephone: (352) 392-4700, extension 4080

Illinois

Chicago Veterinary Medical Association
Chicago
Telephone: (630) 325-1600

Illinois (continued)

C.A.R.E. Pet Loss Helpline, University of Illinois
Urbana
Telephone: (217) 244-2273
Telephone (toll-free): (877) 394-2273
Web site: www.cvm.uiuc.edu/CARE/

Iowa

Pet Loss Support Hotline at Iowa State University
College of Veterinary Medicine
1600 S. 16th St., Ames 50011
Telephone (toll-free): (888) 478-7574
Web site: www.vetmed.iastate.edu/animals/petloss

Massachusetts

Tufts University School of Veterinary Medicine
Grafton
Telephone: (508) 839-7966

Michigan

Pet Loss Support Hotline
College of Veterinary Medicine
Michigan State University, Suite G100
East Lansing 48824
Telephone: (517) 432-2696

Minnesota

*University of Minnesota School of
Veterinary Medicine*
Minneapolis
Telephone: (612) 625-1919

New Jersey

Pet Friends, Inc.
Moorestown
Telephone (toll-free): (800) 404-7387

St. Hubert's Giralda
Madison
Telephone: (973) 377-7094

New York

Animal Medical Center
New York
Telephone: (212) 838-8100

ASPCA
New York
Telephone: (212) 876-7700

Bide-A-Wee Foundation
New York
Telephone: (212) 532-6395

The Broken Bond Pet Loss Hot Line/
Support Group
Rochester
Telephone: (507) 289-8169

Capitol Region Pet Loss Network
Albany
Telephone: (518) 448-5677

Cornell University
Ithaca
Telephone: (607) 253-3932

Ohio
Ohio State University
Columbus
Telephone: (614) 292-1823

Pennsylvania
University of Pennsylvania School of
Veterinary Medicine
Philadelphia
Telephone: (215) 898-4525

Virginia
Virginia-Maryland College of Veterinary Medicine
Blacksburgh
Telephone: (540) 231-8038

Washington
Washington State University, College of
Veterinary Medicine, Pet Loss Hotline
Pullman
Telephone: (509) 335-5704
E-mail: plhl@vetmed.wsu.edu
Web site: www.vetmed.wsu.edu/plhl

Wisconsin
The Rainbow Passage, Pet Loss Support
and Bereavement Center
Grafton
Telephone: (414) 376-0340
E-mail: douglasc@execpc.com

INTERNATIONAL

Australia

The Australian Centre for Companion Animals in Society (ACCAS) operates a national pet-loss grief hotline in Australia.
Telephone: (02) 9746-1911
Telephone (toll-free): (800) 704-291

Canada

International Pet-Loss Resources
Web site: www.pet-loss.net/resources/Int.html

Canadian Centre for Pet Loss Bereavement
Web site: www.petlosssupport.ca

England

The Pet Bereavement Support Service
Telephone (toll-free): (800) 096-6606

New Zealand

Loving Tributes
Web site: www.lovingtributes.co.nz

The Pet Network–New Zealand's Online Guide to Pets
Web site: www.thepetnetwork.co.nz

CONCLUSION

Having It All

We can treat our pets to almost anything we can find, do, or buy for ourselves. The marketplace for pet products and services has exploded in the past several years, and it shows no evidence of decreasing. While some of the items shown in this book may surprise you with their extravagance, they exist because someone is buying them. There is a market for indulging our pets at any financial level. Although some of the options may seem excessive to you, others may find them to be the perfect thing for their pet.

While on a media tour to publicize an earlier book about fashionable dogs, I was confronted by the host of a morning news program (no names will be mentioned, to protect the identity of a popular television personality). He asked me if I was ashamed of myself for promoting such

extravagant behavior and expense lavished upon dogs by their owners. He said that it was unconscionable to spend such large sums on mere dogs while people all over the world went hungry.

I countered his comment with the observation that people who lavish attention upon dogs were kind-hearted people. Wasn't it Gandhi who said that you can learn a lot about a people from the way they treat their animals? I am certain that the very same people who treat their pets well are also committed to making the world a better place for their fellow man. Many are the same people who support charities and work to stop hunger, homelessness, violence, and disease.

I have been "guilty" of the charge of indulging my pets. Indeed, the Introduction shows how I treated my late dog, Tori. She was an adorable little 4-pound bundle of joy, and her sole objective in life was to love me and make me happy. And she succeeded well. I would do anything in my means to take care of Tori. Many of the things I did were as much for my entertainment and delight as for her welfare.

This behavior does not preclude my involvement with the outside world. I am active in the community and philanthropic, donating money to and working for a range of charities. Although I indulge my pet, my heart and resources are still in the right places. And I am joined in this behavior by countless other pet owners.

The late Leona Helmsley has been chastised in the press for leaving twelve million dollars to her Maltese dog, Trouble. The small pup was her ardent companion, and Mrs. Helmsley derived a great deal of happiness from her relationship with the tiny dog. The twelve million left in trust for the dog's care is but a small fraction of her estate. While Mrs. Helmsley left monetary bequests to family, employees, and friends, the vast majority of her estate, worth billions, will be put into the Leona M. and Harry B. Helmsley Charitable Trust, which will provide money to charitable causes.

Conducting the research for this book has been a great pleasure for me. I have had the opportunity to meet and get to know many fascinating and caring people. We are all very different, but in many ways, we are all the same. We have nurturing hearts and respond with warmth and affection to our pets and those around us. Even though it may seem that our animals are indulged and have it all (and many of my friends had made the comment that "in the next life" they wanted to come back as Tori), in truth, our animals give us much more than they receive.

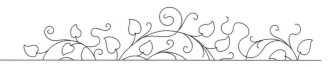

Complete Vendor List from Pet Fashion Week

4 Legged Designs (570) 595-1258; 317 Capricorn Ave., Oakland, CA 94611, U.S.

26 Bars & A Band, Inc. (213) 393-5352; 332 Carrione Ct., Phillips Ranch, CA 91766, U.S.

A Pet's World (802) 366-9015; P.O. Box 1993, Manchester Center, VT 05255, U.S.

Alexander Art (316) 541-2761; 11236 SW 30th St., Towando, KS 67144, U.S.

American Pup (213) 623-7200; 215 E 8th St., Suite H, Los Angeles, CA 90014, U.S.

Andrea Levine Jewelry (302) 888-1488; 1601 Concord Pike, Suite 38 A & B, Wilmington, DE 19803, U.S.

Animal Wrappers, Inc. (954) 748-3355; 5265 NW 108th Ave., Sunrise, FL 33351, U.S.

Animals Matter, Inc. (877) 944-9699; 23790 Hawthorne Blvd., Torrance, CA 90505, U.S.

Asuku America/Sohatek Inc. (310) 696-3054; 1831 Colorado Ave., Suite 800, Santa Monica, CA 90404, U.S.

Bark Avenue Jewelers (412) 486-2016; 301 Grant Ave., Suite 4300, Pittsburgh, PA 15223, U.S.

Bark Vineyards (757) 897-7640; 104 Shaindee Dr., Williamsburg, VA 23185, U.S.

Barking Zoo (212) 255-0658; 172 Ninth Ave., New York, NY 10011, U.S.

Beau Nouveau, LLC (813) 489-5888; 1123 Venetian Harbor Dr. NE, St. Petersburg, FL 33702, U.S.

Bella Creature Comforts (713) 723-0471; 4762 Redstart St., Houston, TX 77035, U.S.

Bonesoir Couture, LLC (727) 374-3646; 2428 Eighteenth St. S, St. Petersburg, FL 33712, U.S.

Bow Wow Collars (401) 333-2925; 163 Roland St., Cumberland, RI 02864, U.S.

BowTie, Inc. (213) 385-2222; 2401 Beverly Blvd., Los Angeles, CA 90057, U.S.

Buddy G's (401) 255-5717; 2 Carriage Cove, Coventry, RI 02816, U.S.

Buttercup & Peanut (253) 265-0931; 6817 Forty-first St. Ct. NW, Gig Harbor, WA 98335, U.S.

Canini, Inc. (518) 762-9606; 25 Pine Ave., Johnstown, NY 12095, U.S.

Caserta Italia (845) 658-9174; P.O. Box 76, Rosendale, NY 12472, U.S.

Cece Kent (866) 232-3536; P.O. Box 2447, Morrison, NJ 07962, U.S.

Chic Paws (415) 331-9379; 1001 Bridgeway, Suite 708, Sausalito, CA 94965, U.S.

Chien Coature (262) 632-1980; 1520 S. Main St., Racine, WI 53403, U.S.

CiboReale, LLC (217) 390-7800; 60 Hazelwood Dr., Champaign, IL 61820, U.S.

Cloak & Dawggie (212) 594-3800; 325 W 38th St., Suite 1501, New York, NY 10018, U.S.

Coco & Max Doggie Distinctions (401) 764-0498; P.O. Box 91118, Johnston, RI 02919, U.S.

Cocojor Hawaii, LLC, Menehune Plantation (808) 394-2162; P.O. Box 26034, Honolulu, HI 96825, U.S.

Creature Couture Inc. (858) 405-6033; 7909 Silverton Ave., Suite 207, San Diego, CA 92126, U.S.

D J Pets (604) 929-2555; 17-1001 Northlands Dr., North Vancouver, BC V7H243, Canada

Diamond Dogs UK Ltd. (408) 245-5552; 1174 Crandano Ct., Sunnyvale, CA 94087, U.S.

Dig (203) 984-8282; 163 Aquidneck Ave., Middletown, RI 02842, U.S.

Disco Lulu (310) 463-9553; 835 Second St., Hermosa Beach, CA 90254, U.S.

Diva-Dog (619) 461-3482; 4850 La Cruz Pl., San Diego, CA 91941, U.S.

Dog Design by Hi-Craft (480) 248-9045; 7975 N Hayden Rd., Suite B122, Scottsdale, AZ 85258, U.S.

Dog in Paris (619) 804-5192; 350 K Street, Suite 403, San Diego, CA 92101, U.S.

Dog Luv by Michele Marcombe (404) 325-9727; 1668 Belle Isle Circle NE, Atlanta, GA 30329, U.S.

DogChewz NYC (212) 762-5855;
1175 York Ave., Suite 14B,
New York, NY 10021, U.S.

Doggie Divine (905) 763-9663;
163 Green Bush Cres., Thornhill,
Ontario L4J 5L8, Canada

Doggles, LLC (530) 344-1645;
6160 Enterprise Dr., Unit G 114,
Diamond Springs, CA 95619, U.S.

Dolores Piscotta (718) 232-1167;
8865 Sixteenth Ave., Brooklyn, NY 11214, U.S.

Dorothy Bauer Designs (510) 527-2431;
702 Harrison St., Unit A, Berkeley, CA 94710, U.S.

Douglas Paquette Accessories
(401) 273-0066; 1 Acorn St.,
Providence, RI 02903, U.S.

E&E Hallström (914) 949-2781; 6 Carlyle Pl.,
Hartsdale, NY 10530, U.S.

Emma Rose Design (401) 624-3259;
69 Roseland Terrace, Tiverton, RI 02878, U.S.

Epiderma Pet (941) 753-6700;
3102 Cortez Rd. W, Bradenton, FL 34207, U.S.

Epiks (866) 463-4746; 4055 Wilshire Blvd.,
Suite 350, Los Angeles, CA 90010, U.S.

Fab Dog, Inc. (877) 322-3647;
155 W 71st St., Suite 1A,
New York, NY 10023, U.S.

Fairytail Couture (732) 516-0542;
241 F Amboy Ave., Metuchen, NJ 08840, U.S.

Farfetched, Inc. (310) 452-0424;
960 Palm Terrace, Pasadena, CA 91104, U.S.

FouFou Dog (416) 628-9983;
155 E Beaver Creek Rd., Unit 24, Suite 187,
Richmond Hill, Ontario, L4B2N1, Canada

Friends of Baby Doll Pliner
(212) 688-6900; 745 Fifth Ave., 25th Floor,
New York, NY 10151, U.S.

Fursacci Canine, Inc. (514) 931-6485;
1415-3577 Atwater Dr.,
Montreal, Quebec, H3H2R2, Canada

Gamboa (415) 533-6730; 584 Castro St., #316, San Francisco, CA 94114, U.S.

Gidget-Gear (941) 355-2220; 333 Suwanee Ave., Sarasota, FL 34243, U.S.

Gooby (866) 466-2959; 4055 Wilshire Blvd. Suite 350, Los Angeles, CA 90010, U.S.

Happy Puppy Academy (862) 778-6265; 2 Tuxedo Dr., Livingston, NJ 07039, U.S.

Haute Diggity Dog (702) 257-0213; 1591 Buffalo Dr., Suite 110, Las Vegas, NV 89128, U.S.

Healing Dog (347) 273-2962; 395 Henry St., #15, Brooklyn, NY 11201, U.S.

Hedy Manon (949) 838-5681; 4321 Colony Plaza, Newport Beach, CA 92660, U.S.

House of Chienelle (480) 924-1309; 3058 E Des Moines St., Mesa, AZ 85213, U.S.

JJ and Me! (845) 866-5000; 621 Portside Dr., Edgewater, NJ 07020, U.S.

Kashwere Furr Me! (908) 604-6677; 11 Briarwood Dr. E, Warren, NJ 07059, U.S.

KRNY Group (716) 627-2606; 6210 Old Lake Shore Rd., Lake View, NY 14085, U.S.

Kwigy-bo (212) 398-1097; 501 Seventh Ave., Suite 508, New York, NY 10018, U.S.

Lands' End (608) 935-4633; 5 Lands' End Ln., Dodgeville, WI 53595, U.S.

Les Poochs (845) 369-6600; P.O. Box 51, Tuxedo, NY 10987, U.S.

Lovely House 82-1031617267; #202 Insung B/D, 88-37 Chungdam-dong, Seoul, Kangnam-gu 135-010, Korea

Lux Designs (866) 582-9589; 1451 Boulevard West, Hartford, CT 6119, U.S.

Luxepets, LLC (310) 314-9837;
1129 Marco Place, Venice, CA 90291, U.S.

Margoff 55-1147947477
Juan Bautista Alberdi; 1029 Olivos,
Buenos Aires 1636, Argentina

Mhound (401) 847-2436; 270 Bellevue Ave.,
Newport, RI 02840, U.S.

Millicent Ltd (201) 444-6098;
10 Leone Court, Glen Rock, NJ 07452, U.S.

Modern Dog magazine (604) 734-3131;
Suite 202, 343 Railway St.,
Vancouver, BC V6A1A4, Canada

Monkey Daze, Inc. (858) 220-3447;
5526 Hamill Ave., San Diego, CA 92120, U.S.

Mrs. Bones (757) 412-0500;
1616 Hilltop West Shopping Center,
Virginia Beach, VA 23451, U.S.

My Charmed Pet (805) 405-6406;
2246 Ben Lomond Dr.,
Los Angeles, CA 90027, U.S.

My Petshirt, LLC (516) 510-3808;
4809 Avenue N, Suite 127,
Brooklyn, NY 11234, U.S.

Nagorka Designs (610) 613-6597;
38 S Broadway, Tarrytown, NY 10591, U.S.

New York Buddies (212) 799-2729;
24 W 68th St., # 3, New York, NY 10023, U.S.

New York Dog (646) 486-1331;
133 W 25th St., New York, NY 10001, U.S.

Northern Moods 31-206646088;
Murillostraat 8, Amsterdam 1077 NE,
The Netherlands

Oliver's Closet (845) 661-9237;
281 W 12th St., New York, NY 10014, U.S.

Oomoaloo 44-7944070121; Unit 25,
Millead Business Center, London N17 9QU,
United Kingdom

Organic-Dog 00-649524548738; Spencer St.,
Remuera, Auckland, New Zealand

Oscar Newman (630) 697-5566; 39 W 511 St., Hyde Park, Geneva, IL 60187, U.S.

Paws Unleashed (718) 701-5568; 6018 Linden St., Ridgewood, NY 11385, U.S.

Pedishe (607) 547-5547; 3 Susquehanna Ave., Cooperstown, NY 13326, U.S.

Pet Business magazine (212) 979-4861; 333 Seventh Ave., 11th Floor, New York, NY 10001, U.S.

Pet Entertainment Network (212) 226-3955; 110 Greene St., Suite 405, New York, NY 10012, U.S.

Pet Gear (802) 438-2231; 192 Sheldon Ave. 105, West Rutland, VT 05777, U.S.

Petote (866) 642-2621; 2444 16th St., 4th Floor, Chicago IL 60608, U.S.

Petsnobs International, Inc. (845) 207-9087; 160 Farm to Market Rd., Brewster, NY 10509, U.S.

Phoebe's Inc. (310) 844-2469; 1421 Aviation Blvd., Redondo Beach, CA 90278, U.S.

Pink Polka Dog (917) 334-0009; 10935 Terra Vista Pkwy., Suite 248, Rancho Cucamonga, CA 91730, U.S.

Planet H, Inc. (718) 383-0453; 300 Kingsland Ave., Brooklyn, NY 11222, U.S.

Poochey Shoos–Presch, LLC (972) 386-0973; 14324 Vintage Ln., Addison, TX 75001, U.S.

Precious Pups Creations (610) 678-0337; 2412 Lexington Dr., Wyomissing, PA 19610, U.S.

Precious Rouge 85-291314393; 2805 Skyline Tower, 39 Wang Kwong Rd., Kowloon Bay, Hong Kong

Preston (978) 356-5701; 44 Mitchell Rd., Ipswich, MA 01938, U.S.

Quattrozampe (415) 864-6615; 1501 Mariposa St., Suite 326, San Francisco CA 94107, U.S.

Retropup, LLC (973) 543-3022;
72 Ironia Rd., Mendham, NJ 07945, U.S.

Robbie Dawg, Inc. (718) 855-1552;
246 Creamer St., Brooklyn, NY 11231, U.S.

Romy and Jacob (514) 342-2366;
1122 Laird Blvd., Suite 21,
Mont-Royal, Quebec, H3R122, Canada

Roxy Hunt Couture (877) 476-9948;
2516-A McMullen Booth Rd.,
Clearwater, FL 33761, U.S.

Royalty's Ruff (917) 664-1527;
6 Banfi Plaza West, Farmingdale, NY 11735, U.S.

Ruff Ruff Couture (310) 271-7118;
8888 Olympic Blvd., Suite 201,
Beverly Hills, CA 90211, U.S.

Ruffluv (718) 237-9655; 232 3rd St.,
Building A1, 207, Brooklyn, NY 11215, U.S.

S&M NuTec—the maker of Greenies
(816) 221-8538; 1 Design Dr. N,
Kansas City, MO 64116, U.S.

Schmitty Says, LLC (212) 580-4819;
27 W 67th St., New York, NY 10023, U.S.

Sexy Beast (212) 929-6428;
145 Avenue of the Americas,
New York, NY 10013, U.S.

Sherpa's Pet Trading Company
(212) 838-9837; 135 E 55th St., 8th Floor,
New York, NY 10022, U.S.

Silver Bones (972) 239-4499;
5925 Forest Ln., Suite 216,
Dallas, TX 75230, U.S.

Sporty K9, Ltd. (512) 266-3320;
4560 Steiner Ranch Blvd., Suite 1211,
Austin, TX 78732, U.S.

Studio Bella, LLC (303) 514-2422;
15797 E Prentice Dr., Centennial, CO 80015, U.S.

Susan Lanci Designs, Inc. (760) 634-1934;
7999 Passeo Esmerado, Carlsbad, CA 92009, U.S.

Tanner & Dash, Ltd. (619) 283-1000;
4562 Alvarado Canyon Rd., Suite R,
San Diego, CA 92120, U.S.

Tartan Hound (716) 627-2606;
6210 Old Lake Shore Rd.,
Lake View, NY 14085, U.S.

Thayer & Ridge, Inc. (516) 365-6175;
239 Park Ave., Manhasset, NY 11030, U.S.

The New York Dog (212) 966-5190;
110 Greene St., Suite 405,
New York, NY 10012, U.S.

The Pet Project 01-14535356494;
Farvergade 2, 2nd Floor,
Copenhagen 1463, Denmark

The Pet Set, LLC (201) 225-1307;
97 Grand Blvd., Emerson, NJ 07630, U.S.

The Puppy Hugger (203) 661-4858;
121 North St., Greenwich, CT 06830, U.S.

Theo Ent. 354-5538313; Dugguvogur 6 104,
Reykjavik, Iceland

Twil Animal (646) 261-9703; P.O. Box 524,
FDR Station, New York, NY 10151, U.S.

Waggin' Wear (888) 220-3885;
54 Van Dyke Ave., Amsterdam, NY 12010, U.S.

Wiggles, Wags, & Whiskers, LLC
(248) 307-9292; 1250 Souter Dr.,
Troy, MI 48083, U.S.

Yellow Dog Design (336) 553-2172;
Dundas Circle, Greensboro, NC 27407, U.S.

ACKNOWLEDGMENTS

This book would not have been possible without the help and participation of a great many people. I must first thank Michael Fragnito, my friend and editorial director at Sterling Publishing Co., Inc. and Meredith Peters Hale, my editor, for suggesting that I once again focus upon the subject of pampered dogs.

This book brought me back to my roots, to my first book, *Dogue,* which was a parody of *Vogue* Magazine. I first learned in 1986 that everything featured in a typical issue of *Vogue* Magazine—the fashions, beauty products, books, movies, vacation destinations, and even celebrities—had a counterpart for dogs! Here, over 20 years later, I discovered that the world of posh pups had expanded to include even more extravagant and delightful choices to share with my readers!

Meredith Peters Hale is a perceptive and intelligent editor, and it has been a pleasure to work with her again. Edwin Kuo is a talented and creative art director and I thank him—as well as Christine Kwasnik (associate design manager), Elizabeth Mihaltse (art director—cover), and *tabula rasa* graphic design (interior designers)—for collaborating with us in the creation of this book. I also thank Jeanette Green (project editor) and Laurel Ornitz (copyeditor), for their attention to all of the details, both large and small, that might otherwise go uncorrected.

I must also thank Carol Blanchette, of Emma Rose Design, who kindly shared her knowledge of the upscale pet fashion business with me, and who generously introduced me to one of her customers, so that I could understand the pet fashion business from the perspective of a consumer.

Truly, the book would not have been possible in its present form without the extraordinary help and participation of Cynthia Hayden, and her adorable 4-pound white Toy Poodle, Precious. Precious served as the image of the book in every chapter. I had envisioned this role for my late dog, Tori, (who was my own 4-pound Maltese bundle of joy), but her absence left a gap that Precious filled in her own delightful way. So, while Tori graces the dedication page and introduction, Precious is resplendent in all of the

chapter openings that follow throughout the book. Cindy was an enthusiastic and eager collaborator, arranging for photo sessions, and sharing Precious's extensive wardrobe and enviable lifestyle with me, and now you, the readers of this book. Thank you, Cindy, for becoming such a good friend, and for ensuring the success of the book by sharing your darling Precious with all of us. In the next life, I want to come back as Precious....

My thanks also go out to Chelle Calvert, photographer extraordinaire, for providing photography for this book, as well as my last one, *Dogs by Design*. Your work is wonderful, and I thank you for all of your hard work on both book projects.

I must thank two friends of mine in the pet-product industry. Gayle Martz, of Sherpa's Pet Trading, has remained a friend since the time we met, many moons ago, when we shared

exhibit booths at trade shows. I am in awe of the great success she has made of Sherpa's, but I am certainly not surprised! I must also reach out to another friend from those years long ago, Linda Coffey, who was the founder of Haute Canine, a manufacturer of upscale treats and accessories for dogs. I remember the times we spent at the trade shows, sharing the booth and dreaming of the success that we would one day enjoy. I must also thank her for helping me select my dear dog, Tori. Tori knew that she would lead a pampered existence when she saw the two women pull up to the kennel in a Porsche convertible! So, Linda, thanks for that, and for so much more!

I would like to thank Bob Vetere, the President of The American Pet Products Manufacturers Association (APPMA), for speaking to me at the show in Orlando, and answering my questions about the industry. I would also like to thank Jennifer Murray, Annie Rotberg, Tracey Wilson, and Andrew Darmohraj, of their trade show department, for making my days at the show so productive and pleasant.

I want to extend my thanks to Alexa Cach of Pet Fashion Week, who invited me to join her for a tour of the trade show. She was kind to spend a part of her busy day with me, and for this I, and the readers, will be forever grateful.

I must also thank the myriad of pet-product designers, manufacturers, and distributors who spent time with me at the trade shows (the APPMA show and Pet Fashion Week), and who generously provided me with product information, images, and samples, for inclusion in this book. You are the heart and soul of this industry, and your work brings happiness to a great many people (and their pets).

I thank all of the dogs of my memory and heart: Nubie, Tori, Morgan, Annabel, Bubbles, Suds, Bucky, Mort, Sassy, Susanna, Charlie, Kelly, Beanie, and Brownie.

I thank my late husband, Irwin Hochberg, for teaching me all that I know about life, love, and the world. You made me the person I am today, and I will be forever grateful for the life we shared.

Most of all, I thank my husband, Bob Wood, for believing in me, even when I did not believe in myself. I love you.

PHOTO CREDITS

Title page; pages 13 (right), 22 (bottom), 23, 46 (bottom), 56, 145, 152: Photos by Fifi & Romeo, Inc., Japan, Yutaka Iwata

Dedication page (center), 116 (right), 117: © Pop Art Pet, LLC

Contents, 47, 48: By Poochie of Beverly Hills. www.poochieofbeverlyhills.com, (888) 867-0400

Page viii: Phyllis Pesaturo, as seen in *Florida International* Magazine

Pages 3, 5, 11, 21, 34, 39, 43, 52, 62, 71, 81, 87, 105, 113, 118, 133: KSH Pet Photography, 28241 Crown Valley Pkwy., #465, Laguna Niguel, CA, 92677, (949) 429-8797, www.ksh-petphotography.com

Pages 7, 88, 95 (left), 96: Simon the Bulldog © The Picture People

Pages 9, 24–25, 58, 92: Daniel Gagnon for Pet Fashion Week

Page 12, 15, 16, 17, 18, 19, 73, 99, 101, 102, 103, 104, 123: Chelle Rohde Calbert, www.designerdoggies.com

Pages 13 (left), 66: Courtesy of Beanies and Belvedere

Pages 14, 37: Courtesy of Fou fou dog

Pages 16 (right), 44, 54, 57, 59, 68, 72: Myrna Hujing at Studio-Pets, myrna@studio-pets.nl, www.studio-pets.nl for Haute Diggity Dog

Page 22 (left): Burberry

Pages 26, 135: Photo by Traer Scott for Pet Fashion Week

Page 27: Andrea Levine Jewelry: 14K white gold and pink sapphire poodle necklace, and 14K and diamond signature open paw print necklace

Page 28: Copyright 2006. Poochey Shoos, LLC

Pages 29, 30: Photo courtesy of Oscar Newman

Pages 31, 33, 150: Rob Upton Photography, Bethlehem, PA, for Ilene Hochberg's Stylish *Knits for Dogs* (Quarry Books), photobyrob@enter.net, photobyrob@rcn.com

Pages 35, 36: Courtesy of John Paul Pet

Page 41: Pet Clin® is brought to you by TMC Pet Vending Solutions (TMCPetVending.com)

Page 45: Cheengoo.com, (415) 337-8481, info@cheengoo.com

Page 46: Top: Kevin McGowan Photography for Bella Creature Comforts

Page 51: Exclusive Designs by Lori Grey for Bow Wow House

Page 60: Pet Goods

Page 63: Wags and Wiggles Daycare, Rancho Santa Margarita, CA, www.wagsandwiggles.com

Page 69 (left): Sushi dog toys courtesy of Charming Pet Products (www.charmingpet-products.com)

Page 76: Bash Dibra and dogs

Pages 83, 85: Sherpa Pet Group, Photos by Demitrius Balevski of Infinity Photography, Little Falls, N.J., (973) 256-4000, infinitybydm@optonline.net, www.infinity8Photo.com

Page 90, 91, 92 (left): Courtesy of Emma Rose Design

Page 95 (right): By Author Shari Cohen; illustrations by Nadia Komorova; Songs by Cantor Marcelo Gindin. Published by Five Star Publications, Inc. (www.AlfiesBarkMitzvah.com)

Page 98: Wags & Wiggles Daycare, Rancho Santa Margarita, CA, www.wagsandwiggles.com

Page 106: (top) Courtesy of Animal Fair Media, Inc.; (bottom) Bark Magazine Cover © Bark Magazine; photograph by Stephanie Rausser (www.thebark.com)

Page 109: Courtesy of Modern Dog Magazine

Page 114, 115: Photo by Dick Westphal; paintings by Tillamook Cheddar

Pages 125, 127: Claire Chew, Luxepets, LLC, www.luxepets.com, (310) 314-9837

INDEX

Adler, Jonathan, 50
AKC survey, 99
American Kennel Club (AKC), 8, 11, 20, 103–104
American Society for Prevention of Cruelty to Animals (ASPCA), 103–104, 127, 130
Aromatherapy products, 38–40
Bakeries, dog, 88–89
Bark Mitzvahs, 95
Beckloff, Mark, 89–90
Beds, dog, 43, 44–50
Birthday parties, 88–90
Blanchette, Carol, 92, 93–94
Books, about dogs, 20, 105. *See also* Magazines; *specific topics*
Breath freshener, 59
Breeds, 11–20
 choosing, 19–20
 going everywhere with owners, 12–15
 large, 17
 media affecting popularity, 16
 mixed, 19
 most popular, 11
 paternity tests to identify, 124
 toy, popularity and characteristics, 12–17
Broderick, Matthew, 77
Cach, Alexa, 27–28
CD, to make dogs happy, 88
Celebrity dog lovers, 3–4
 cuisine inspired by, 53–54
 dogs in weddings of, 91
 dressing their dogs, 23
 photographed with dogs, 12–13
 training dogs of, 77–80
Cheddar, Tillamook "Tillie," 114–116
Choosing dogs, 19–20
Clothing, 21–33
 athletic, 70

Fifi and Romeo, 22, 23, 46
 Hollywood fashion hounds, 23
 increased obsession with, 22, 23
 industry overview, 21–22
 knitting projects, 31–33, 112–113
 Pet Fashion Week and, 24–29, 135–143
 wedding attire, 91–94
Crafts, 112–117
 books on, 112–114
 knitting projects, 31–33, 112–113
 pup art projects, 114–117
Crates, 50, 83
Crates and doghouses, 83
Dancing, 67–68
Death of dog, 125–132
 comfort and support after, 126, 127–128, 129–132
 euthanasia and, 125
 memorials, keepsakes, ashes, and urns, 126–127
 support hotlines, 129–132
 sympathy cards to send, 126
DeJoria, John Paul, 35, 36
Dental care, 35, 38, 122–124
Designer dogs, 19
Dibra, Bashkim "Bash," 74–79
DiFante, Mario, 27–28
Dishes, 60–61
Doggie daycare, 63, 81
Doghouses, 50–51
Dog runners, 64
Dye, Dan, 89–90
Emma Rose Design, 6, 27, 29, 90, 91–94, 138
Euthanasia, 125
Filming pets, 96
Finances
 cheap chic tips, 6, 40, 67
 money spent on pets, 8–10, 130
 small vs. large dogs, 15–17

Fitness and exercise, 62–70
 books, 68
 clothing, 70
 dancing, 67–68
 doggie daycare and, 63
 dog runners, 64
 dog walkers, 62–63
 hydrotherapy equipment, 64
 organized activities, 67
 outdoor gear/toys, 66–67
 pedometers and, 65
 playing with toys, 68–70
 regular walks, 62
 swimming and boating, 65–66
 treadmills and equipment, 64–65
Food, 52–61
 celebrity-inspired cuisine, 53–54
 desserts, 57–59
 dishes for, 60–61
 dog bakeries and, 88–89
 for finicky eaters, 57
 flavor-enhancing food toppers, 57
 gourmet-style, 56–57
 natural, healthy, 54–55
 for parties, 88–89
 recipes, cookbooks, and Web sites, 52–53, 89–90
Fragrances, designer, 40. *See also* Aromatherapy products
Geller, Tamar, 79–80
Grooming, 34–42. *See also* Dental care
 aromatherapy products, 38–40
 designer fragrances, 40
 doggie massage, 39, 85, 86
 doggie wigs in lieu of, 24
 Fauna Sauna heat treatment, 40–42
 John Paul Pet products, 35–36
 polishing toenails, 39
 salon services offered, 34
 spa experiences, 36–42
 suggested treatment, 39

Health issues. *See also* Dental care; Veterinarian
 complex, recommended centers for, 120–122
 natural treatments for, 122
 pet insurance and, 119–120
 testicular implants, 124
Heartbeat, bed with sound of, 51
Helmsley, Leona, 134
Hochberg, Tori, viii, 1, 134
Holiday parties, 95–96
Homeopathic remedies, 122
Hotels, pet-friendly, 85–86
Humane Society of the United States (HSUS), 83, 104, 127
Huneck, Stephen, 50
Hydrotherapy equipment, 64
Insurance, pet, 119–120
Internet, pet/owner communities, 101–103
Jewelry, 6, 27, 114, 127
John Paul Pet, 35–36
Knitting projects, 31–33, 112–113
Lassie, 53
Love, unconditional, 1, 2, 4
Luxurious trappings
 availability of, 6
 naysayers of, response to, 133–134
Magazines, 105–111
 covering Pet Fashion Week, 28
 pet parodies of, 75
 recommended, 106–111
Massage, doggie, 39, 85, 86
Microchips, 82–83
Mixed-breed dogs, 19
Ogden, Dr. Kim, 88
Orthopedic beds, 49
Outdoor fitness toys and gear, 66–67
Panter, Bobbi, 38
Parker, Sarah Jessica, 77–79
Parties, 87–97. *See also* Weddings
 birthday, 88–90
 books on, 96
 dog bakeries and, 88–89

 elaborate, 88
 gifts and, 87
 holiday and seasonal, 95–96
 planning steps, 97
Paternity tests, for dogs, 124
Paul Mitchell for animals. *See* John Paul Pet
Pedometers, 65
Pet Fashion Week, 24–29
Pet Fashion Week vendors, 135–143
Pet products. *See also specific products*
Pet products, affordable, 6, 40, 67
Pets, ownership statistics, 7–8
Pocket pets, 2
Polishing toenails, 39
Precious
 background and lifestyle, 4–6, 15, 20
 dental care, 122
 designer apparel of, 5–6, 29–30, 91
 dining delights, 52, 60
 dog beds of, 44
 dog mother of, 5, 100
 favorite magazines of, 106
 pampered grooming of, 39
 parties for, 88
 playing with toys, 69–70
 training of, 80
 traveling and, 81, 85–86
 vet visits for, 118
Pup art projects, 114–117
Relationships. *See also* Social life; Weddings
 AKC Valentine's Day survey and, 99
 dog qualities and, 99, 100
 jealousy of dogs and, 100
 pet-lover dating sites, 101
 singles and their dogs, 100
 sleeping with dogs and, 100
 Sleeping with dogs, 100
Social life, 98–104. See also Relationships
 ASPCA/humane society participation, 103–104

 neighbors recognized by their dogs, 99–100
 online pet/owner communities, 101–103
 singles and their dogs, 100
Spa experiences, 36–42
Stairs, for pets, 51
Swimming and boating, 65–66
Testicular implants, 124
Toys, 48, 50, 67, 68–70
Training, 71–80
 animal behaviorist for, 73–79
 Bash Dibra and, 74–79
 books and materials, 72–73, 78, 79, 80
 celebrity dogs, 77–80
 preventing damage by, 71–72, 73–74
 by Tamar Geller, 79–80
 "Three P's" of, 78
Traveling, 81–86
 car-trip gear, 82
 crates or travel bags for, 83–85
 pet-friendly hotels, 85–86
 preparing/packing, 81–83
 sedatives for, 83
 things to take, 83
 travel agents and resources, 84
 vet visit before, 82–83
Treadmills, 64
Van Patten, Dick, 53–54
Veterinarian. *See also* Health issues
 microchip from, 82–83
 pet insurance and, 119–120
 pre-trip visit to, 82–83
 visiting (and reasons for), 118–119
Wedding attire, 91–94
Weddings, 90–95, 100
Wegman, William, 50
Weiss, Mindy, 90–91
Wigs, doggie, 24

ABOUT THE AUTHOR

Ilene Hochberg is an internationally best-selling author whose parody books help millions of people laugh over the absurdities of life and enjoy healthier times with more success and less stress. It's been said that laughter is the best medicine....

Her examination of the anthropomorphism of animals (i.e., treating our pets as people) has been met with great acclaim. The books *Dogue, Catmopolitan, Vanity Fur, Forbabes, Good Mousekeeping, Who Stole My Cheese?!!!*, and *Stylish Knits for Dogs* are perennial favorites and have been featured in various media, including CNN, *Good Morning America, Jeopardy, Newsweek, Forbes,* the *Wall Street Journal, Vanity Fair, Good Housekeeping, Cosmopolitan,* and *Publishers Weekly.* She is also the author of *Dogs by Design* (Sterling, 2006).

Ms. Hochberg's education includes a B.S. in Design and Environmental Analysis from Cornell University. She is a member of Mensa, has been an instructor at the Parsons School of Design, holds a Black Belt in shopping, and is a confirmed knitter. She has shared her life with a succession of beloved canine companions and is the proud parent of her new step-dog, Kelly, a 12-year-old Miniature Dachshund. In other words, she is the ideal person

*Ilene Hochberg
and a furry friend*

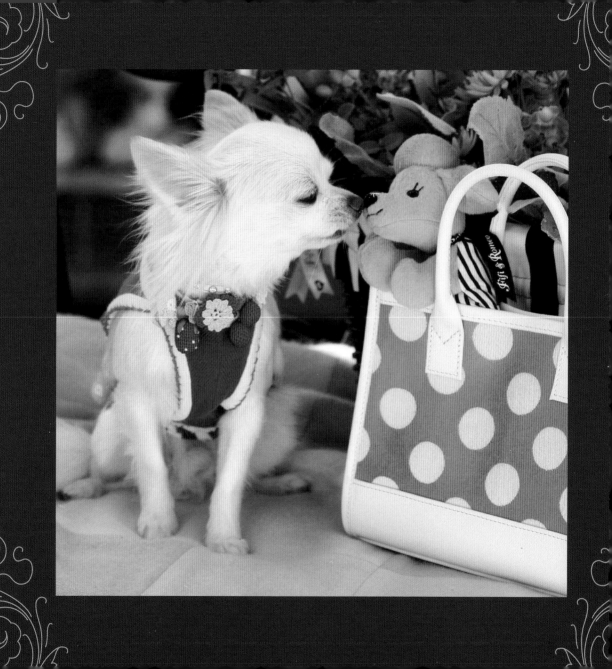